The Voice ❧ of the Mother

The Voice ✦ of the Mother

Embedded
Maternal Narratives
in Twentieth-Century
Women's Autobiographies

Jo Malin

Southern Illinois University Press
Carbondale and Edwardsville

"Birth" by Sue Mullins is reprinted from the *Massachusetts Review*,
© 1972 The Massachusetts Review, Inc.

Library of Congress Cataloging-in-Publication Data

Malin, Jo, date.
 The voice of the mother : embedded maternal narratives in twentieth-
century women's autobiographies / Jo Malin.
 p. cm.
 Includes bibliographical references (p.) and index.
 1. American prose literature—Women authors—History and
criticism. 2. Autobiography—Women authors. 3. English prose
literature—Women authors—History and criticism. 4. American
prose literature—20th century—History and criticism. 5. English
prose literature—20th century—History and criticism. 6. Mothers
and daughters in literature. 7. Mother and child in literature. 8.
Motherhood in literature. 9. Mothers in literature. 10. Narration
(Rhetoric) I. Title.
PS388.A88M35 2000
818'.508093520431—dc21 99-16863
ISBN 0-8093-2266-8 (cloth : alk. paper) CIP

The paper used in this publication meets the minimum requirements of
American National Standard for Information Sciences—Permanence of
Paper for Printed Library Materials, ANSI Z39.48-1992. ∞

For my mother and my daughter

Contents

Preface

Look at me: autobiography, it is I!
 —Phillipe Lejeune, *On Autobiography*

Women catch courage from the women whose lives and writings they read, and women call the bearer of that courage friend.
 —Carolyn Heilbrun, *The Last Gift of Time*

I write this preface after my book is almost complete. In it, I try to sort out two issues: Why have I chosen to write about this topic? Why have I chosen these texts? I also introduce myself as a writer whose personal voice enters this text.

Why do women's autobiographies continue to fascinate me? Why am I most interested in the story each woman writes about her mother and the place of this story in the text? For, as my book discusses at length, each of the women autobiographers I include definitely does write of her mother and this biographical telling is central in the given woman's autobiographical text.

Like Lejeune, I must have chosen the topic because I am interested in writing autobiographically myself. In fact, just the process of selection of texts and critical views of the texts is an autobiographical act. The careful reader can see what the process reveals about any writer. My readers can see that I am fascinated with, even fixated on, the mother/daughter relationship and its evidence in a woman's text, not all women's texts, but many. Further, it reveals my continual and continuing interest in my own relationship with my mother and more recently my relationship with my daughter. I am very close to both these women. One's body held my own and gave me life. The other was carried in my body and nourished at my breast. I am constantly aware of an overlap, a joining of voices, histories, and genetic markings in both relationships.

Thus, it would be an artificial act to separate my own autobiography from my work on the texts of Woolf, Suleri, Rich, Moraga, Lorde, Nestle, Steedman, Allison, Modjeska, and Chernin. In fact, the reader will find two voices in this text, one critical and theoretical and one personal. The personal one tells my own story around the margins of the critical voice's domain. The texts prompt the personal telling. The writers are particularly important to me because I feel the connection of shared experience. And, at this point in my life, I've lived with each so long that we are what

Carolyn Heilbrun calls "unmet friends" (154). I feel as if they are my friends and role models who give me courage and support.

Thus, I have come to the realization that I am writing my own autobiographical text as I write this sustained analysis of women's autobiographies. Without a desire to understand and to share my own story, in which I have embedded my mother's story, my choice of topic would never have sustained my commitment to a connection between theory and practice. Because the topic is so "personal," I am caught fast in the constant questioning, sorting, and connecting that the process has become. Reading their texts provided the inspiration for my own writing. They were more than inspiration, however. Conversations, dialogic exchange, and engagement occurred between the voices of these writers and my own autobiographical voice. Bakhtin describes such a dialogue: "The second speaker is present invisibly, his words are not there, but deep traces left by these words have a determining influence on all the present and visible words of the first speaker. We sense that this is a conversation . . ." (*Problems* 197).

Today, I find that different autobiographical texts pull me. I fall in love with texts in which the writer is exploring and happily discovering solitude. Aging interests me, and texts by women who are aging as solitaires with their own houses or spaces, in particular. I suppose I like to read about what is happening in my life or will happen in the next ten years or so.

I own my own beautiful house now for the first time, and all the rooms are mine to live in. I see calm, peaceful, orderly, mostly white spaces all around me. I feel so privileged and sometimes even guilty to have such good fortune. I have feelings similar to those Alix Kates Shulman describes in *Drinking the Rain:* "[Now] I find that solitude, far from being the price, is turning out to be the prize" (51).

Acknowledgments

Many, many people helped and supported me and my work on this book. My first thank-you is to my mentor, Sidonie Smith. Her ideas and writings were my inspiration. She tirelessly coached, critiqued, and communicated with me from several different places around the world. My closest friend and fellow traveler throughout this project has been Victoria Boynton. Her own brilliant work and her love and friendship were central.

My family supported and believed in me with more love and understanding. My debt to all of them—my mother, father, son, daughter, daughter-in-law, sister, brother-in-law, aunt—is very great.

So many others assisted and helped me that I can only list their names: Sylvia Fenton, Tom Kowalik, Ted Rector, Linda Biemer, Albert Tricomi, all of the Harridans Morris dancers, all of my staff, Diane Geraci, Rachel Cassel, Ronni Goldberg, Carol Clemente, Anne Mamary, Lonny Bush, Barbara Walling, Ann Higginbottom, Barb Adams, Hilary Ross, Deanna France, and Fran Goldman.

The Voice of the Mother

1
Introduction

> Meaning is created not through a single voice, but in the interaction of voices—that is, in dialogue.
>
> —Diane Price Herndl, "The Dilemmas of
> a Feminine Dialogic"

> Imagine a dialogue of two persons in which the statements of the second speaker are omitted, but in such a way that the general sense is not at all violated. The second speaker is present invisibly, his words are not there, but deep traces left by these words have a determining influence on all the present and visible words of the first speaker. We sense that this is a conversation, although only one person is speaking, and it is a conversation of the most intense kind, for each present, uttered word responds and reacts with its every fiber to the invisible speaker, points to something outside itself, beyond its own limits, to the unspoken words of another person.
>
> —M. M. Bakhtin, *Problems of Dostoevsky's Poetics*

Every woman autobiographer is a daughter who writes and establishes her identity through her autobiographical narrative. Many twentieth-century autobiographical texts by women contain an intertext, an embedded narrative, which is a biography of the writer/daughter's mother. My analysis of this narrative practice examines texts by Virginia Woolf, Sara Suleri, Kim Chernin, Drusilla Modjeska, Joan Nestle, Carolyn Steedman, Dorothy Allison, Adrienne Rich, Cherríe Moraga, and Audre Lorde, all daughters and writers of autobiographical texts. These texts raise interesting questions about autobiography as a genre and about a feminist writing praxis that resists and subverts the dominant literary tradition.

I begin my analysis of embedded maternal narratives from this starting point: The notion of separation, individuation, autonomy is problematized by textual evidence in this group of autobiographies. It is impossible to separate the autobiography of the daughter from the biography of the mother in the texts I have chosen. In them, "distinctions" between autobiography and biography, or text and intertext, blur, even disintegrate.[1] The two life stories overlap, and the mother, the object of the biographi-

cal narrative, becomes a subject, or rather an "intersubject," in her daughter's autobiography. These texts become conversations or dialogues between a mother and a daughter. There are two subjects engaged in a dialogue, and the topic of their conversation is as important as is the dialogic mode of the text. These writers do not use a single authoritative or monologic voice and, thus, create an alternate literary form.

Feminist Theories of Maternity, Identity, and Embeddedness

To begin my analysis of embedded maternal narratives in this group of twentieth-century women's autobiographies, I need to discuss, briefly, related issues within feminist theory. In her essay "The Failure of Biography and the Triumph of Women's Writing," Anna Kuhn notes a "breakdown of subject/object boundaries . . . a sense of interconnectedness and interrelationship" in the women's texts she discusses (17). The narrator and narratee are sometimes enmeshed and interrelated, she writes, as the subjectivities of mother and daughter overlap. My study, as well as Kuhn's, of writing practices that do not foreground autonomy or categorical uniqueness, is grounded in two decades of feminist cultural and psychoanalytic theories of maternity, the problematic of motherhood, and the mother-daughter relationship.

In her 1981 essay, Marianne Hirsch began her review of feminist scholarship on the mother-daughter relationship with Adrienne Rich. She writes that *Of Woman Born* "announces" in both content and form "the work that followed on mother daughter relationships." Hirsch further asserts that this study is an important starting point for feminist theory. She writes: "The study of the mother-daughter relationship situates itself at the point where various disciplines become feminist studies, as well as at the point where the feminist areas of a number of disciplines intersect" (202).

In feminist literary theory, these sociological, psychoanalytical, and historical studies have helped to elaborate the historically specific nature of the concept of a unitary, autonomous individual, the Enlightenment subject. In addition, these norms have been critiqued as Western, heterosexual, and capitalistic. In her analysis of mothers and daughter, Suzanna Walters theorizes: "[A]utonomy and individuation are highly valued characteristics of a *capitalist* society and as such are naturalized so as to appear as unassailable *truths* about the nature of adulthood and maturity" (10). Vivien Nice comments on the same qualities in her study of mothers and daughters. She notes the valuations of normalcy and maturity a male, heterosexist value system places on independence and separation. Her interest is in psychological theories: "Individuation, separation, independence—the language of the individualized, competitive, hierarchical male—are considered developmentally mature . . . connectedness, mutuality, concern with relationships are seen as developmentally immature" (9). Nice's ulti-

mate concern is with a definition or discourse of adulthood that is equated, developmentally, with the child's separation from the mother.

Using the objects relations theory of D. Winnicott, Alice and Michael Balent, and others, Nancy Chodorow revised Freudian and Lacanian theories of human development. Her analysis focused on the so-called pre-Oedipal stage, a developmental stage during which both male and female children remain attached to the mother and to an early form of language associated with the literal rather than the figurative. Chodorow proposed that "in any given society, feminine personality comes to define itself in relation and connection to other people more than masculine personality does." Because, according to Chodorow, the female's experience includes a continued identification with her mother, her separateness is less complete. "In psychoanalytic terms, women are less individuated than men" (44).

An interest in language and psychological development underlies Julia Kristeva's writings on the semiotic language of the body of the mother as opposed to the symbolic realm of the father.[2] Hélène Cixous's theories surrounding the concept of écriture féminine or female-marked language also focus on language and development and a pre-Oedipal language or poetics that is pre-symbolic and literal. In agreement with Margaret Homans, however, I find Irigaray's theoretical and autobiographical work most applicable to a study of the

> implications of this presymbolic mother-daughter relation for figurative and literal language in our present culture. . . . Unlike the son, the daughter does not . . . give up this belief in communication that takes place in presence rather than absence, in the dyadic relation with the mother prior to figuration. (13–14)

Irigaray's writings on the mother-daughter relationship also provide an introduction to the related issues of anger, ambivalence, and confinement in the women's autobiographical texts I discuss. Her own daughterly narrative, "And the One Doesn't Stir Without the Other," is a telling of nonseparation and nonautonomy that reveals the underside of this meshing of subjectivities. She writes: "I grow angry, I struggle, I scream— I want out of this prison" (60).

Lastly, I have used Sidonie Smith's theory of women's voices as those that speak from a marginal position within patriarchy and of the resultant or accompanying poetics that marginal voices speak in autobiographical texts.

Finally, I wish to problematize the "categories" of mother and daughter and question a biological essentialism of the mother-daughter relationship. This consideration is part of "a question posed in increasingly sophisticated ways by feminists: 'What are "women"?'" as Leigh Gilmore writes. The question, she states, has no "commonsensical answer" and

has "tumultuous recent critical histories" (17).[3] It is important to note that mothers are sometimes "women" who give birth to daughters and to sons. They are also women who enter into a relationship of mothering without the biological connection of pregnancy or birth; or women whose wombs or ovums are part of the gestation of a child; or women who give birth and "lose" their children because of choice, coercion, or disaster. Daughters can similarly have identities that are not tied to a single biological relationship or "event."

Lejeune and Autobiography Theory

Next, I wish to take a step back and discuss autobiographical contracts in order to explain how I arrived at the point of describing my model of a hybrid, conversational practice. My discussion begins with Phillipe Lejeune and two of his essays in particular: "The Autobiographical Pact" and "The Autobiographical Pact (bis)." In 1973, Lejeune published the first of these essays. It centers on his attempt to define autobiography as a genre and to distinguish it from both fiction and related forms of autobiographical writings such as memoirs, diaries, autobiographical novels, or autobiographical poems. Lejeune begins his typological/descriptive essay with a definition of autobiography that starts with the reader's position or perspective, which, he states, "is mine, the only one I know well" instead of with the mind of the author (4). While his definition covers texts written since 1700 and includes only European literature, he does not state that these are the only texts he is interested in, but that his definition is most appropriate for this temporal and geographical grouping. He sets forth the following as a modified definition of autobiography, modified, that is, from his earlier discussion in *Autobiography in France:* "DEFINITION: *Retrospective prose narrative written by a real person concerning his own existence, where the focus is his individual life, in particular the story of his personality*" (4).

Lejeune continues to analyze four elements determinative of his definition. First, the "form of language" in autobiography is both narrative and prose. Second, the "subject treated" is an individual life and the story of a personality. Third, the "situation of the author" is that both author and narrator are identical and have a name that refers to a real person. Finally, the "position of the narrator" is doubly limited. The narrator and the principal character are "identical" and a retrospective point of view predominant. Lejeune admits that all four categories are not equally restrictive and that the question of proportion must be considered in classifying texts. That is, if a text contains most of the elements, it can be included within the genre of autobiography. However, two of the conditions must be met for autobiography to exist: The author and the narra-

tor must be identical, and the narrator and the principal character must be identical. Thus, his definition of the genre may be stated in a distilled descriptive statement: "[T]he *author*, the *narrator*, and the *protagonist* must be identical" (5).

Lejeune discusses the problems raised by his use of "identical" and "identity." How can the identity of the narrator and the protagonist be expressed in the text? How are identity and resemblance different?[4] The identity of both narrator and protagonist are most often expressed through the use of the first person. However, it is important to distinguish between a person inscribed grammatically and an actual individual outside of the text. Lejeune, thus, proceeds to his central point in the essay. It is the proper name of the author, narrator, and protagonist that distinguishes autobiography generically. He argues that the author is more than a person. S/he is, rather, a person who writes and publishes. The proper name of this author who writes and publishes appears on the title page of the text and through a long-established social convention links the text to a real person. We know this person is real because of the existence of verifiable vital statistics such as municipal records of births, deaths, and so forth.

Lejeune's simple criterion of the proper name as the marker of identity in published autobiographical texts ties together all markers of personal identity in a text. The name on the title page identifies one person as author, narrator, and protagonist in an autobiography. The autobiographical pact, then, is a pact that the author forms with the reader that affirms the referential reliability of this authorial identity. The name on the title page of the text, which is part of the textual evidence, announces autobiographical identity for the reader of the text. Lejeune sums up and defends his categorical assertions and his central focus on the author's signature:

> I think that this definition, far from being arbitrary, brings out the essential point. What defines autobiography for the one who is reading is above all a contract of identity that is sealed by the proper name. And this is true also for the one who is writing the text. (19–20)

Autobiography and biography, according to Lejeune, are referential texts. They convey images of the real that the reader accepts as part of the "autobiographical pact" formed with the writer. The text itself offers the reader evidence needed to form this pact. There is no need to go beyond the text and into the world beyond: "The text itself offers this last word at the very end, the proper name of the author, which is both textual and unquestionably referential" (21). The autobiographical pact, based on the proper name, marks the genre as a contractual genre for the reader. Therefore, it is distinguishable by the type of reading it engenders.

"The Autobiographical Pact (bis)" was published in 1982. In it, Lejeune

deconstructs and questions the certainty of many of his statements in his earlier essay. At the same time, however, he confesses to a continued faith in autobiography, referentiality, and the self. He concedes his doubt in a belief of the self as more than a fiction but then continues with a discussion of its functioning as experiential fact (Lejeune xiv). He states: "I have no regrets. After all, if we rely on this definition [of autobiography], it is because it corresponds to a need . . . [T]he definition is useful" (121). In this later piece, he also describes an autobiographical discourse as a narrative in which the question of "who am I" is answered by a narrative that tells "how I became who I am" (124). In this essay, Lejeune allows for more free play within the notion of identity but maintains his earlier description of the autobiographical space as one formed by a pact between reader and author and one in which referentiality is established by the act of publication of a discourse with a proper name, even a pen name or pseudonym, on the first or last page.

I use Lejeune's theory of a referential pact formed with the reader of autobiography and the referential space that such a pact creates to analyze texts that are actually neither autobiography or biography, but are both. The "global" evidence of publication—the text carries the author's name on its title page—creates the contractual relationship with the reader and governs the reading of these texts as autobiographies. Within each of the texts I discuss, however, a second narrative that is also a referential text occupies the contractual space formed with the reader. The act of embedding her mother's biography, rather than establishing it as a separate text, gives the embedded biographical narrative a shared place within the readerly contracted space and brings the subject of this narrative into a position of "identity" rather than "resemblance."

Women's Conversational Practices

Thus, to go one step further, the daughter/writer who embeds her mother's biography, rather than publishing it separately, places her mother's narrative in a textual relationship next to or overlapping her own autobiographical text, which can be described as a "dialogue" or "conversation" between the texts as "intertexts" and between the subjects as "intersubjects." Because both texts rest within the same space formed by an autobiographical pact with the reader, an equal measure of referentiality is assumed for the biography and the autobiography. In these narratives, the biographical protagonist, the mother, has a clear and insistent voice and an identity that joins the voice and the identity of the autobiographical protagonist, the daughter, in dialogue. These daughters are not simply telling their mothers' stories. They are engaged in conversation.

Several theorists, such as Anna Kuhn, have analyzed texts by women

writers that cross the generic boundary between biography and autobiography. In her essay noted earlier, Kuhn discusses two texts by German women writers that "explode expectations" of biography. Both writers' texts are as much autobiography as they are biography. I note her study because in it she discusses a textual phenomenon that superficially resembles the narrative practice I am theorizing. Kuhn describes a "breakdown of subject/object boundaries . . . a sense of interconnectedness and interrelationship" in the texts that she analyzes "which invoke traditional generic expectations of both biography and autobiography only to disappoint those expectations" (14, 17). Kuhn asserts that the biographer and the subject of the biography are sometimes interrelated and, further, that a resisting writing practice can be deduced. She writes:

> By transcending traditional norms of canonical genres, von Arnim and Wolf create new literary forms that substitute a dialogic structure for phallocentric discourse: a conversation between two women replaces the single authoritative (and authoritarian) narrative voice. (15)

Kuhn explores two specific texts in which the narrators adopt a conversational practice in their texts. In each, there is a dialogue between the writing subject and the subject of a biographical narrative. Her textual analysis supports her position that feminist writing practices resist asserting authorial supremacy over biographical material and, thus, allow the object of the narrative to assume a subject position. I find Kuhn's work useful and hope to extend her idea of conversations between two women in biographical texts to my analysis of women's autobiographies with embedded maternal narratives.

Bakhtin and the Dialogic

In general, I want to remain faithful to the everyday uses of the words "conversation" and "dialogue." We all know what a conversation or a dialogue is. The telephone and electronic mail may have replaced the tête-à-tête, but conversation remains. In addition, however, Mikhail Bakhtin's theories of the dialogic relation provide some useful concepts and vocabulary for the textual analyses that follow this introduction.

Mikhail Bakhtin's major interest in all of his writing was the centrality of dialogue in language, literature, or culture. The dialogic, as he defined it, is a model of communication in which consciousness and subjecthood is formed through constant engagement with others and their languages or dialects. Each "social dialect" expresses shared experiences and values of a particular group. These groups and their languages are infinite in number, and their intersections remain open and constantly changing.[5]

Allon White has described Bakhtin's notion of language as "the con-

crete and ceaseless flow of *utterance* produced in dialogues between speakers in specific social and historical contexts" (123). This model of human communication, which describes most everyday speech, opposes dialogic to authoritative or "monologic" speech, which is closed and in which meaning is fixed. There are strong forces that keep dialogic utterances open and unfinished. In human discourse, as in texts, Bakhtin theorizes, centrifugal forces push utterances toward further openness to the outside world and to further dialogic engagement. And, he writes, "in each of the contexts that dialogize it, the discourse is able to reveal *ever newer ways to mean*" (*Dialogic* 346). At the same time, centripetal forces constantly strive to effect closure on a speech act or a text. A necessary tension between openness and closure exists at all times in the use of spoken language as it does in the creation of a text.

Language is more than the material of written or spoken texts for Bakhtin, however. Language is an expression of social identity. And, like language, subjectivity or consciousness is also shaped through social dialogic interaction. In her essay "Speaking in Tongues," Mae Gwendolyn Henderson discusses his concept of the "subjective psyche" constituted as a "social entity" that opposes Freud's notion of the psyche. Bakhtin, she highlights, wrote: "The processes that basically define the content of the psyche occur not inside but outside the individual organism. . . . Moreover, the psyche enjoys extraterritorial status . . . [as] a social entity that penetrates inside the organism of the individual person" (*Marxism* 25, 39).

Bakhtin's assertion that subjects are social, not individual, radically opposes the "bourgeois ideology" and the Western tradition of individualism. Even inner speech, the "semiotic material of the psyche," has been heard and learned as outer speech. Subjectivity is thus socially constructed because all speech that we internalize carries meaning from the social interactions in which it occurs. In his introductory essay to *Problems of Dostoevsky's Poetics,* Wayne C. Booth describes this important tenet of Bakhtinian philosophy. He writes:

> To me it [his system] seems clearly to rest on a vision of the world as essentially a collectivity of subjects who are themselves social in essence, not individuals in any usual sense of the word. . . . We come into consciousness speaking a language already permeated with many voices—a social, not a private language. From the beginning, we are "polyglot," already in process of mastering a variety of social dialects. . . . [A]nyone who is not an "ideologue," respects the fact that each of us is a "we," not an "I." Polyphony, the miracle of our "dialogical" lives together, is thus both a fact of life and, in its higher reaches, a value to be pursued endlessly. (xxi)

If a literary work is to attain such a "value" and to mirror the dialogic nature of human existence, the writer must resist the impulse to close out

multiple voices prematurely in order to impose a monologic unity on his/ her work. The modern novel or novel of the "Second Stylistic Line," Bakhtin writes, can best allow many voices to engage dialogically, since the language of the novel is not simply the author's voice or her/his authorial language. The modern novel, instead, reflects the "multiplicity of the era's languages" (*Dialogic* 410–11). The label of "novel," however, can include other genres. Bakhtin's description of a text that represents the dialogic quality of human communication can extend to autobiography. He theorizes a tendency or possibility in literature rather than a narrow classification of texts and, also, sees the novel as a model for all writing in periods when the genre is predominant. Bakhtin's "Discourse in the Novel" has, thus, been very useful to feminist and poststructural theory. I find that it provides some concepts that can be employed to create a strategy to approach many women's texts. However, his earlier work, "Author and Hero in Aesthetic Activity" (ca. 1920–1923) in *Art and Answerability,* is even more specifically useful in my own analyses of women's autobiographies with embedded maternal biographies. In this early essay, the relationship between self and other, author as self, hero as other, is central. The relationship of the author to his or her hero is theorized and explored as the dialogical relation that is requisite for an aesthetic act to take place. However, the author's creation of a subject or hero is even more, that is, it is the dialogically related creation that allows the author to know himself or herself. Bakhtin states:

> An author creates, but he sees his own creating only in the object to which he is giving form, that is he sees only the emerging product of creation. . . . And, in fact, such is the nature of all creative experience: they [authors] experience their object and experience themselves *in* their object. (6–7)

In "Author and Hero in Aesthetic Activity," Bakhtin examines the "author's architectonically stable and dynamically living relationship to the hero." This relationship is the "necessary foundation" for all texts, but it can assume very diverse characteristics in different genres and with different authors (4). He describes the case of biography among other genres and autobiography as a most particular case or type of biography. The section entitled "Autobiography," especially, provides a very interesting basis for a strategy to use in working with the embedded maternal biographies in this group of women's texts.

Most traditional (often male) biographies approach a monologic and authoritative voice as they chronicle great deeds and accomplishments. These are the "historical" texts that describe the life of a great man. In these biographies, the author writes about an object, an other who is observed. But, in the maternal biographies that daughters include in their

own texts, there is a blurring of who is the author and who is the hero of the text. Since there are actually two texts, one within the other, there can be said to be two heroes (with a single author). The mother becomes a second hero in the daughter's autobiographical text because her biography, in which she is the hero, is embedded in the daughter's text. Bakhtin, in fact, describes the voice of the mother as the voice of another who is within all of us as we remember childhood. His words could easily describe these auto/biographical texts: "In our ordinary recollections about our past, it is often this other who is active, and it is in his value-tones that we remember ourselves (in remembering our childhood, this bodied other within ourselves is our mother)" (152–53). Clearly, as the daughter writes her autobiography, she is remembering her childhood. It is this other who gives meaning to the memories of her past. Bakhtin states:

> My body, my exterior, my dress; various inner-outer particulars of my soul; certain details and particulars of my life that cannot have axiological significance and cannot be axiologically reflected in the historical-heroic context—in mankind or in a nation (everything that is inessential historically, yet is present in the context of my life): all this assumes axiological weight and gains meaning and form in the loving consciousness of another. (157)

These mother-daughter texts are all narratives of what he describes as the daily particulars of a life, the nonhistorical or nonheroic context. Further, the dialogicity of these texts derives from the presence of the other, mother, as a true subject rather than an object. Bakhtin does not take the next step, which would be to deconstruct the notion that only the heroic is historical, but he lays a foundation for such a feminist notion—that is, many women's texts center on daily experiences, and many narratives of women's lives do not fit most traditional definitions of biography or autobiography. Bakhtin, himself, seems aware that there are texts in which the "material" is the personal, the "particulars of my soul," and that they stretch the boundaries of canonical, often male autobiography and biography.

In addition, Bakhtin writes of a relational rather than alienational otherness. What has been seen as a negative blurring of ego boundaries may be instead a strategy for subverting the monologic "word of the father" of male autobiography. Two women's voices (a daughter's and a mother's), in conversation, can subvert the monologic, authoritative autobiography (usually male) of accomplishment and great deeds: "the striving to live a heroic life, to achieve significance in the world of others, to win fame and glory" (156).

Thus, Bakhtin's notion of the dialogic relationship between author and hero allows one to imagine and model a discourse that is a conversation between two heroes as subjects. The women writers I discuss use the

boundary between biography and autobiography as a location that permits such a dialogic tendency or possibility to enter their writing praxis and their texts. Within each of these texts, a conversation or dialogue is not always "spoken" in a conventional sense. Rather, these texts are often modeled on inner dialogues. Each writer not only "thinks" her mother's story as an inner dialogue with herself before putting it on the page, but her voice and her mother's voice are dialogic in her inner thoughts. Thus, as Bakhtin writes, even when one speaker is "silent," there can still be dialogue as each speaker influences the other's speech. What appears to be an autobiographical monologue is, in fact, a dialogue. The daughter/writer's word or utterance is formulated with constant regard to her mother's word. Thus, what exists is a dialogic text. Within the text, the subjects are "talking," having a conversation. They are conversant—associated with—and they are conversant—familiar.

In conclusion, what I theorize is a hybrid form of autobiographical narrative containing an embedded narrative of the mother. The textual relationship between the two narratives is unique among texts in the auto/biographical canon. This alternative narrative practice is both autobiography and biography rather than one or the other. It is marked by a breakdown of subject/object categories as well as auto/biographical dichotomies of genre. Each text contains a "self" that is more plural than singular, yet neither. All of the texts that follow contain a feminist writing practice that resists the use of a monologic, authoritative narrative voice.

I use conversation or dialogue as a model in my analyses. In all of the texts, the daughter/writer as a subject attempts to speak to her mother as a subject rather than about her as an object. This model allows for a discussion of texts that are related by the subject of the conversation, between mother and daughter: What are they talking about? I have built a schema based on the conversations within these texts. My schema accounts for the topic of the conversation—What are the mother and daughter talking about?—and the form of the dialogue—Is the mother's voice taken from her daughter's memories, from a transcription of her spoken voice, from her own writings, and so forth? All of the texts are conversations, yet the mode or origin of the mother's voice within her daughter's text varies greatly. In Virginia Woolf's and Sara Suleri's texts, for example, the mother's narrative voice is written through the daughter's elegiac memories of it, after the death of the mother. In others, however, the mother's voice, taken from her own autobiographical writings, is placed in dialogue with the daughter's written narrative voice. Joan Nestle's mother left her daughter the sole legacy of autobiographical writings. Nestle writes: "When my mother died, she left me two satchels of scribbled writings. Many of these fragments were written on the back of

long yellow ledger sheets, the artifacts of a bookkeeper" (78). Kim Chernin's text contains two speakers, daughter and mother. The mother's voice is transcribed by her daughter from recorded interviews specifically arranged for the writing of Chernin's text.

In chapter 2, I discuss two autobiographical texts in which the topic of the conversation is space and, in particular, houses. In Virginia Woolf's *Moments of Being* and Sara Suleri's *Meatless Days*, the conversations are about closets and courtyards, upstairs and downstairs, beds, dressers, and tea tables, windows and mirrors. In both texts, the mother's voice, in dialogue with her daughter's, is drawn only from memories. Julia Stephen died at age forty-nine, when Woolf was just thirteen, and Surraya Suleri died when the daughter/writer was a young adult. In addition, both autobiographers narrate a maternal absence or inaccessibility before their mothers' deaths. Woolf writes about memories of her mother as a "dispersed" presence in a very large family. Suleri describes her mother's life in Pakistan as a prolonged visit. Her narrative is the story of a welcomed guest in her husband's country and in Urdu, his language, but also a guest who never seems a stable presence in her daughter's childhood.

In both texts the conversation is about protected and intimate space within the house that housed the daughter's childhood. To analyze the conversations within these two autobiographies, I have used the psychological and philosophical theories of Gaston Bachelard. In *The Poetics of Space*, Bachelard attaches a psychological theory of the human subject to the localization of experience in the inhabited spaces of human life and, in particular, to the house. He theorizes that the intimate and solitary experiences of the unconscious are located and experienced within these interior domestic spaces. Thus, in order to understand these experiences, one must study these "homey" locations.

Chapter 3 is a discussion of autobiographies that contain a dialogue about intimacy and bodies, specifically the female bodies of a daughter and her mother. Bathing, grooming, and bed-sharing are talked about, sometimes with reticence. Also, each autobiographer, in her dialogue with her mother, sometimes uses a rhetoric that is erotic or romantic. And, at the same time, this rhetoric is tied to an emancipatory feminist political agenda.

I compare conversations about intimacy, sexuality, and women's bodies in each of the following texts: Adrienne Rich's *Of Woman Born: Motherhood as Experience and Institution*, Cherríe Moraga's *Loving in the War Years: lo que nunca pasó por sus labios*, Joan Nestle's *A Restricted Country*, and Audre Lorde's *Zami: A New Spelling of My Name: A Biomythography*.

Chapter 4, "Conversations about Material Things, Longing, and Envy," takes up Carolyn Steedman's *Landscape for a Good Woman: A Story of Two Lives* and Dorothy Allison's *Bastard out of Carolina*. Carolyn Steed-

man's autobiographical text, *Landscape for a Good Woman: A Story of Two Lives,* "is a book about things . . . and the way in which we talk and write about things . . ." (23). The focus is her mother's desire for material things and the concrete unavoidable fact of her envy for these things. The text is a conversation about this class-based longing for material objects and, in particular, mother and daughter's gender-based longing for clothing. The "talk" is about fashion: patent-leather Mary Janes, voluminously skirted dresses, upswept hair. Dorothy Allison's autobiographical text, *Bastard out of Carolina,* can be read along with Steedman's text because it, too, unfolds through conversations focusing on hunger and longing for economic security.

The subject positions of the mother in Steedman's and Allison's gendered, working-class texts are linked economically to men through obligatory heterosexuality, through sexual vulnerability to abuse, rape, or domestic violence, and through pregnancy. The mother's body in these texts is a site of power and life, through maternity, as well as loss of power.

Chapter 5 is an exploration of two contemporary texts, *In My Mother's House* by Kim Chernin and *Poppy* by Drusilla Modjeska. Both auto/biographical narratives center on the issue of voice and its fixing and unfixing in a written text.

In Chernin's text, the mother tells stories, and her daughter records them. Formal appointments were made over a seven-year period to "tell stories" and, thus, record them. This process of capturing or recording the stories, however, changes them. Both the content and the voice change through the process of transmission. Roles change and sometimes mother and daughter "collaboratively" tell and write stories, merging their voices. Because the auto/biography was published in a second, revised edition, Chernin is able to write about changes in her mother's voice that she knows began at a public reading, at which her mother was in the audience. The speaking and writing of a voice over time and the changes brought about by the fixing of text in publication is uniquely addressed in Chernin's text.

I conclude this chapter and this analysis of daughters' texts with an Australian biography/autobiography/novel. Drusilla Modjeska's *Poppy* was published in 1990 by an Australian press. She also engages in a conversation with her mother about storytelling and voice. The mother whose voice she engages in dialogue, a voice taken mostly from her diaries and letters, is drawn from the daughter's memory as well as her imagination. However, Modjeska warns her reader, at the beginning of her text, that nothing within "should be taken simply as literal" (312). Instead, the reader is told, she has "created" a voice to have a conversation with, to *talk* to.

Modjeska deconstructs traditional biography, as a genre, as well as

"the fictional paradox of truthfulness" (308). Her text grapples with the difference between "evidence" or historical fact versus imagination. Just as the notion of "separation" between the mother's biography and the daughter's autobiography is problematized in all of the texts I have discussed, so is the notion of separation of what is experience and what is imagination in *Poppy.*

After a brief afterword, my final chapter is actually a coda. It is an essay entitled "Babies and Books: Motherhood and Writing," in which I explore a small group of women's autobiographies written by mothers, rather than daughters. I want to question the daughter-centered bias in much of feminist theory and criticism of autobiography, as Marianne Hirsch does in *The Mother/Daughter Plot.*[6] Why are there so few autobiographical texts written with a mother as subject of her own text? Why has direct authorization of the mother's narrative been foregrounded by the story of the daughter in twentieth-century autobiography? I begin to find answers to these questions with an analysis of the textual inscription of the voice of the mother, as writer, in the following texts: Tillie Olsen's *Silences, Her Mothers* by E. M. Broner, Julia Kristeva's "Stabat Mater," Jane Lazarre's *The Mother Knot,* and Ursula K. Le Guin's "The Fisherwoman's Daughter." In addition, in the coda, I use my own experience, as a mother who writes autobiography, as one possible "filter" to read and analyze texts written by mothers.

2

Conversations about
Space and Houses

I say mother. And my thoughts are of you, oh, House.
House of the lovely dark summers of childhood.
 —O. V. de Milosz, "Melancholy"

Always in our daydreams, the house is a large cradle.... Life
begins well, it begins enclosed, protected, all warm in the
bosom of the house.
 —Gaston Bachelard, *The Poetics of Space*

She was the whole thing; Talland House was full of her; Hyde
Park Gate was full of her.
 —Virginia Woolf, "A Sketch of the Past"

Mamma [is] that haunting word at which narrative falls apart.
 —Sara Suleri, *Meatless Days*

In Virginia Woolf's *Moments of Being* and Sara Suleri's *Meatless Days*,
the "conversations" between mother and daughter are about space and
houses. In both texts, the mother's voice, in dialogue with her daughter's,
is drawn only from memory. Julia Stephen died at age forty-nine, when
Woolf was just thirteen, and Suleri was a young adult when her mother
died. Both autobiographers also narrate an experience of maternal ab-
sence or inaccessibility when their mothers were alive. Woolf remembers
her mother as a "dispersed" presence in a very large family: "What a jumble
of things I can remember, if I let my mind run, about my mother; but they
are all of her in company; of her surrounded; of her generalized; dis-
persed" (84). Suleri describes her mother's life in Pakistan as a prolonged
visit. Her Welsh-born mother, Mair Jones, becomes Surraya Suleri when
she marries a Pakistani, but she remains a guest in her husband's country
and in Urdu, his language.[1] As a "guest" she never seems a stable presence
in her daughter's childhood. In addition to her geographical and linguis-
tic identities, her mother's career as a university teacher, the persistent de-
mands of a large family, and her need for solitude and quiet made her

"invisible . . . difficult to discern" to her daughter. Suleri writes: "Like the secluded hours of afternoon, my mother would retract and disappear, leaving my story suspended until she reemerged. I think it was a burden to her to be so central to that tale" (154, 157).

In both texts, much of the dialogue between mother and daughter is about space within the house that "housed" the daughter's childhood. To analyze these conversations within these two autobiographies, I use the psychological and philosophical theories of Gaston Bachelard. In *The Poetics of Space*, Bachelard attaches a psychological theory of the human subject to the localization of experience in the inhabited spaces of human life and, in particular, to the house. He theorizes that the intimate and solitary experiences of the unconscious are located and experienced within these interior domestic spaces, and, thus, in order to understand these experiences, one must study these "homey" locations. His theory of psychoanalysis, one he terms "Topoanalysis," is, then, a "systematic psychological study of the sites of our intimate lives" (8).

Bachelard specifically chooses to examine images of houses as "felicitous space" or "eulogized space." These are images of spaces that human beings love and are attracted to. Houses we have lived in, thus, become more than inert boxes. He theorizes that "[t]he house image would appear to have become the topography of our intimate being. . . . [and] there is ground for taking the house as a *tool for analysis* of the human soul" (xxxvi–xxxvii).

The images of home and house in his own text are often maternal. The house has a "warm bosom" and arms that hold. It is a protective, intimate, enclosed space that he compares to a "large cradle." In memories of that first house where we are born, he states, we participate in the "original warmth" and the "original fullness of the house's being. . . . It is as though in this material paradise, the human being were bathed in nourishment" (7–8). This maternal image is of a womb-like space, the most protected of houses.

In one of his very provocative maternal descriptions, house and mother are one. He narrates a memory of a night of terror and survival in a seaside house during a storm. This small house that is not much more than a hut offers maternal protection and, in fact, becomes his mother:

> Everything swayed under the shock of this blow, but the flexible house stood up to the beast. . . . Though the shutters and doors were insulted, though huge threats were proffered, and there was loud bugling in the chimney, it was of no avail. The house clung close to me, like a she-wolf, and at times I could smell her odor penetrating maternally to my very heart. That night she was really my mother. (45)

In this passage, the image of the house does not come from a nostalgia for

childhood but is one of survival and protection within a space that is maternal. The mother of this image is strong and fierce "like a she-wolf." She has an odor that "penetrates maternally" and therefore is a sexually embodied mother. This image of a maternal house is linked to images drawn from the mythology of the Great Mother or Great Goddess rather than a "feminized" and powerless figure of motherhood. His imaginative experience, in a house at the heart of a cyclone, allows him to go beyond "the mere impressions of consolation that we feel in any shelter" and to participate in the dramatic events sustained by the "combatant" house. The security of the house is associated with its strength and power to protect its inhabitants.

Bachelard further theorizes that memory is housed in space rather than in time and that space contains compressed time. The imagination is not capable and not in need of remembering images of duration, but, rather, it holds the memory of a space where the experience occurred. Further, human beings need enclosed space for shelter and protection of the imagination as well as the body. Even when an individual is virtually homeless, any inhabited space, however precarious, "bears the essence of the notion of home" (5). But without some semblance of shelter, a human being is "a dispersed being." Without the space to daydream, one is not nourished. He/she needs protected space "in the cradle of the house" before being "cast into the world" (7). Memories of any intimate space where one experiences moments of solitude remain most indelible.

The poet uses images of house and home because they are images of the spaces where daydreaming is experienced and the most intimate experiences occur. The poet is, thus, able to move others most deeply by invoking such images. Bachelard describes this element of the poetic process. He writes:

> Thus, by approaching the house images with care not to break up the solidarity of memory and imagination, we may hope to make others feel all the psychological elasticity of an image that moves us at an unimaginable depth. Through poems, perhaps more than through recollections, we touch the ultimate poetic depth of the space of the house. (6)

Bachelard's focus on poetry does not exclude other genres such as autobiography and biography. Writers of autobiography have used images of the house to move the reader at such "an unimaginable depth." Autobiographical texts often begin with a narration of the writer's childhood in the first house that sheltered intimate daydreams.

Following Bachelard's theory, the house and its poetic images in texts have "maternal features." Many women's autobiographical texts can be analyzed by focusing on such images. In Woolf's *Moments of Being* and

Suleri's *Meatless Days*, house images and other spatial images are especially important. Images of vacated space predominate, however. In these texts, the house images are particularly "maternal" because the mother's presence in life and in the text is fragmentary. Each of these writer/daughters' narratives describes a lack of a maternal person, a mother in the flesh. House images may, in fact, substitute for mother images.

Also, images of home and death are inextricably entwined in these dialogues between a daughter and her remembered mother. The embedded narrative is elegiac and clearly affected by absence. In her essay, "At the Threshold of the Self: Women and Autobiography," Linda Anderson comments on the notion of an "aesthetic form which is structured around an absence" (69). Anderson does not describe such a form. In this chapter, I describe a possible form and theorize its attributes.

I begin my analysis with some additional questions about these texts. Why do these writers also use other spatial metaphors, besides the metaphor of the house—architectural and geographic—to describe their losses? Woolf, for example, uses the image of a cathedral to describe the experience of her mother's death. Perhaps the loss of a mother is large, as a house is large to a small girl, or larger, like a cathedral, and may be hushed like a museum or a library. The very sound of small feet on marble or wood echoes in large spaces. Woolf, as a young girl, senses her small size and the feeling that she is alone, not nurtured or protected, in these vast empty spaces.

Suleri's images of house and home speak to the experience of outside and inside. She describes a geographical sense of nonbelonging that reflects a postcolonial woman's experience. She also describes many homes rather than the single house of her childhood.

I also want to question the effect of the mother's death on these autobiographies. Does the mother die in the text if she dies in life? Her voice is not absent, but in what ways is the voice different? Feelings of abandonment are described by both writers. In fact both describe experiences of a second family death (of their sisters) as the death of surrogate mothers.

Lastly, I question the nature of authorial intent and the writing of the text as gesture or ritual of mourning in these texts. Or, is it possibly a care-taking ritual performed on the mother's narrative rather than her body? Neither Woolf nor Suleri was present at the moment of her mother's death. They were not the ones who provided care for their mortally ill or injured mothers nor did they groom their bodies for burial.[2] I do not intend to find final answers for these questions. Instead, I pose them as background for my analyses and for future discussion.

Virginia Woolf, "Reminiscences"

In 1976, a collection of previously unpublished autobiographical pieces by Virginia Woolf was published. Woolf was not writing for publication

and would probably have continued to revise these pieces had she lived longer. The first piece, "Reminiscences," was written when she was twenty-five. It is addressed to her nephew, Julian, son of her stepsister Vanessa Bell, and is, in part, remembrances of Vanessa, their mother, Julia Stephen, and sister, Stella Duckworth. Stella died less than two years after her mother. She was twenty-eight.

The text begins, almost immediately, with a spatial description of Woolf's childhood before her mother's death. Life was orderly and predictable. The "inside" and "outside" experiences were distinct and neatly divided. She writes: "Our life was ordered with great simplicity and regularity. It seems to divide itself into two large spaces. . . . Earth gave all the satisfaction we asked. One space was spent indoors, in the drawing room and nursery, and the other in Kensington Gardens" (*Moments* 28). Within the indoor space of the house, the nursery contained a "dark land under the nursery table . . . peopled with legs and skirts" (28–29). This image describes the short or "low" world of children who have their own play houses within larger adult houses, often constructed from furniture that adults use for other purposes. Woolf also writes about her retreat, even as a young child, from the difficulties of family relationships, into an immersion in the satisfaction to be had from outdoor things: "There were smells and flowers and dead leaves and chestnuts . . ." (29).

The center section of "Reminiscences" is about Woolf's mother and her death. It is a description of loss in spatial terms. Household images predominate. Her mother's voice is taken from memories, and Woolf comments on the lifeless quality in her representation of this voice. Any written voice, she writes, lacks life, but death makes transcription especially lifeless. She writes:

> Written words of a person who is dead or still alive tend most unfortunately to drape themselves in smooth folds annulling all evidence of life. You will not find in what I say . . . any semblance of a woman whom you can love. It has often occurred to me to regret that no one ever wrote down her sayings and vivid ways of speech. . . . (36)

In this and other similar passages, Woolf describes an actual craving for conversation, a desire to *talk* to her mother and to hear her voice. She yearns for a maternal presence. Using Bachelard's theory of the house as a maternal presence and noting that the house is the only "maternal object" for Woolf as a motherless woman helps in understanding why her text is a series of house/home images. Also, Woolf's memories of experiences with her mother are compressed, and, thus, so are the spaces that are the setting for the memories. She narrates: "Her life had been so swift, it was to be so short, that experiences which in most have space to expand themselves and bear leisurely fruit, were all compressed in her" (32).

In this early section of her autobiographical text, a major topic of dialogue between daughter and mother is about space and pattern in a more abstract sense. With compression, extremity of pain and loss may appear even larger. Julia Stephen is described as a person so large in the lives of family and friends that she represented major patterns and systems of *space*. Her movements seem to carry great significance and weight. Woolf writes: "All lives directly she crossed them seemed to form themselves into a pattern and while she stayed each move was of the utmost importance" (35). Her significance in these lives, within her daughter's youthful perceptions, is portrayed as a phenomenon as great as a weather front, another vast spatial entity. She writes:

> Living voices in many parts of the world still speak of her as of someone who is actually a fact of life . . . they speak of her as of a thing that happened . . . Where had she gone? . . . She died when she was forty-eight . . . her death was the greatest disaster that could happen; it was as though on some brilliant day of spring the racing clouds of a sudden stood still, grew dark, and massed themselves; the wind flagged, and all creatures on the earth moaned or wandered seeking aimlessly. (39–40)

This very dramatic description of the effect of her mother's death on the entire city or even a wider expanse—weather patterns that ring the entire planet of earth—is part of a dialogue with the voice of an immensely powerful mother. This effect on the daughter makes everyday talk very difficult. The daughter approaches her mother's voice in a worshipful manner. Also, the anger of sharing this dialogue with "voices in many parts of the world" is revealed in the text. Her mother's voice, in memory, is always engaged in multiple conversations with many people. The mother's voice is scarce in the daughter's text as it was inaccessible in life. The scarcity of her presence in life and in the text further compresses the embedded narrative and the dialogue.

"A Sketch of the Past"

Virginia Woolf began "A Sketch of the Past" on April 18, 1939, when she was almost sixty. The last entry is dated November 17, 1940, four days prior to her own death. Before the end of the first paragraph of the text, the exploration of her relationship with her mother has begun: "So without stopping to choose my way, in the sure and certain knowledge that it will find itself—or if not it will not matter—I begin: the first memory" (*Moments* 64). This section of Woolf's memoir is a narrative of her very early memories of her mother and the meaning of these early memories. The earliest, her first "moment of being," is a visual memory of her mother's lap. Woolf sees the fabric of the flowered dress she was

wearing "very close; and [I] can still see purple and red and blue, I think, against the black; they must have been anemones, I suppose" (64). She places herself on a train traveling to St. Ives because this placement "artistically" links the memory to another, which also feels like a first memory.

Woolf's other "first" memory is "in fact . . . the most important." This is also the first one, in this second fragment, in which she narrates her mother's biography using predominately house/home images and, also, begins a conversation about the everyday details of living in the houses of her childhood, before and after her mother's death. She states: "If life has a base that it stands upon, if it is a bowl that one fills and fills and fills—then my bowl without a doubt stands upon this memory" (64). The memory is also a very early one, perhaps of infancy. She remembers lying in the nursery at St. Ives and hearing waves breaking and seeing the light shift as the wind blows the yellow window blind. The memory is of "the purest ecstasy I can conceive" (65). Woolf's memoir later reveals an extremely painful ambivalence toward her mother, but at the beginning of the text, the unconditional immersion in the ecstasy of the moment is all. The imagery ties the memory to both birth and sexuality— the rhythm of the waves breaking, the purest ecstasy—as well as domestic space.[3] Life is described as a bowl, a domestic implement that can be used for food or wine or may be filled with water for washing implements or food or for bathing. The nursery is the setting for this memory, a room associated with infancy and maternal care. The description of the yellow window blind and the sound of the "acorn" at the end of its pull-cord connect both sunlight and a very specific household sound to the earliest memory of her mother. In this memory the child is housed in a protective space that can be compared to Bachelard's depiction of the house as a "large cradle" where "life begins well, it begins enclosed, protected, all warm in the bosom of the house" (7).

Woolf's mother died when she was thirteen, the age of puberty. The loss of this mother who was "the whole thing" and the source of "such ecstasy as I cannot describe" brought an absolute end to her childhood:

> [S]he was the centre; it was herself. This was proved on May 5th, 1895. For after that day there was nothing left of it. I leant out of the nursery window the morning she died. It was about six, I suppose. I saw Dr. Seton walk away up the street with his head bent and his hands clasped behind his back. I saw the pigeons floating and settling. I got a feeling of calm, sadness, and finality. It was a beautiful blue spring morning, and very still. That brings back the feeling that everything had come to an end. (84)

She is once again in the nursery, the place of the memory that is the base her life stands upon. The feeling of finality, the "feeling that life had come

to an end," is spatially and temporally described. The window, the street, even the time (six o'clock, morning) and the season (spring) situate the daughter in a particular room of her house, as the realization of her mother's death descends upon her.

Her mother's death is described as the death of a presence that was "the very centre of that great cathedral space which was childhood" (81). Her mother's voice is dominant in her daughter's autobiographical text, but it is also diffused or generalized. She is a presence as big as childhood and as vast as two large houses with many rooms. Woolf writes:

> I suspect the word "central" gets closest to the general feeling I had of living so completely in her atmosphere that one never got far enough away from her to see her as a person. . . . She was the whole thing; Talland House was full of her; Hyde Park Gate was full of her. . . . I see now that a woman who had to keep all this in being and under control must have been a general presence rather than a particular person to a child of seven or eight. (83)

Woolf's image of her mother's presence as atmosphere or a presence that fills a house derives, in part, from her young age when her mother died. She felt her mother's presence as larger than life because she had not yet separated from her to the independence of adulthood. Also, her relative size and the size of the space she occupies at seven or eight creates a perspective that translates a woman's body into an "atmosphere" or a "general presence." The entire image is of a house within a house.

Secondly, the size of her family and its child care needs disperses her mother's presence. After a short period of closeness to her mother and her body as an infant, she experiences her mother along with her siblings rather than alone. She describes the youngest of them as "us four." They remained as a "group" of children and playmates until Woolf was an adolescent. She relates the separation of "us four" into individuals to images of separate rooms rather than a shared nursery. She writes, "By the time I had that room, when I was fifteen that is, 'us four' as we called ourselves had become separate. That was symbolized by our separate rooms" (125).

The conversation about house-space continues throughout "A Sketch of the Past." Life is organized through furniture and rooms. The tea table is the "heart" of the family; her parents' double-bedded bedroom is its "sexual centre; the birth centre, the death centre" (118). Her father's study is the "brain" of the house. Architecture is personified and associated with intimate memories that it houses. The family's entire life follows a binary division contained within an architectural division: "Downstairs there was pure convention; upstairs pure intellect" (157). Woolf's own room, given to her at age fifteen, contains a living half and a sleeping half, which often overlapped, but are described separately as were "those two lives

that the two halves symbolized" (124). The topography of the multiply divided house further isolated Woolf from her mother. Vast spaces, from a child's perspective, and many rooms associated with discrete functions did not provide a sense of nearness to her mother. Their lives did not physically overlap very much in this Victorian house.

The death of Woolf's mother led her to search for a substitute mother or mother figure. Stella, her twenty-six-year-old stepsister, had been forced into the role of assistant mother and wife, even before Julia Stephen's death: "They were sun and moon to each other; my mother the positive and definite; Stella the reflecting and satellite" (96). Later, she assumed a centrality within the family unit by literally bringing light into the house and, thus, ending the period of mourning: "It was Stella who lifted the canopy again. A little light crept in" (95). Stella's death, following less than two years after her mother's death, was a devastating blow:

> I remember saying to myself after she died: "But this is impossible; things aren't, can't be, like this"—the blow, the second blow of death, struck on me; tremulous, filmy eyed as I was, with my wings still creased, sitting there on the edge of my broken chrysalis. (124)

The loss of mother and sister is described as the loss of home and the shelter it provided. Woolf uses the image of a compromised or threatened building that reminds one of Bachelard's psychological theories of the house: "to have had that protection removed; to have been tumbled out of the family shelter; to have had it cracked and gashed" (137). The memory of the deaths of her mother and sister is described using images of lost protection and shelter from the harsh elements of the world outside of her protected childhood houses. These deaths removed more than two women from her life. Childhood ends as the domestic shelter of life is "cracked and gashed" with the deaths of the mother and sister "who should have made those years normal and natural" (136–37).

Moments of self-hatred and confusion connected with her body begin before her mother's death. Some of these moments, also, are anchored to objects of the house. There is her sexual abuse by her stepbrother: "There was a slab outside the dining room door for standing dishes upon. Once when I was very small Gerald Duckworth lifted me onto this, and as I sat there he began to explore my body" (69). His abuse of her and his assertion of patriarchal power further break and gash the sheltered world of her childhood. The slab outside the dining room door is a place for dishes. Her body is handled like an inanimate household object for Gerald's use and convenience. This experience is closely linked to the memory of a vision that turns on another domestic object, a mirror. She remembers the image of her reflection in a mirror with a vision of an animal behind her. These "moments of being" are part of a process that separates the young Virginia from her body and the possession of it for

her own pleasure. Sidonie Smith describes these traumatic "moments" as "horrifyingly vivid memories that signify . . . [Woolf's] transition" from childhood and from the "experience of preoedipal bondedness and boundlessness in which her body and her mother's body are sources of ecstasy" (*Subjectivity* 88).[4]

She was aware of the narrowing of her life within the space of the house because of her gender in other ways, also. Downstairs life, the conventional half, was female but constricted. The upstairs life was intellectual and exciting, yet also associated with the brutality of her father. Woolf describes the pain of the psychological abuse she associated with her father: "If instead of words he had used a whip, the brutality would have been no greater" (*Moments* 145).

Woolf's depiction of her relationship with her mother is the core of her book, to use Adrienne Rich's phrase. For her there is no conclusion to this obsession and central topic of conversation. Two voices, one taken from memories, talk on and on about houses and the sheltered life that was broken by early loss. At age sixty, when she wrote the second text, she is still grappling with this obsession and a painful ambivalence toward her mother, who, even in death, shadows her daughter's life and text. In "A Sketch of the Past," there is very little talk of her fear of becoming too much like her mother. Her autobiographical novels, especially *To the Lighthouse*, however, do explore the complexity of the relationship including her feelings of ambivalence and anger. She announces in her autobiographical text that her obsession with her mother ended with the writing of this novel. Woolf writes:

> It is perfectly true that she obsessed me, in spite of the fact that she died when I was thirteen, until I was forty-four. Then one day walking round Tavistock Square I made up, as I sometimes make up my books, *To the Lighthouse*; in a great, apparently involuntary, rush. One thing burst into another. Blowing bubbles out of a pipe gives the feeling of the rapid crowd of ideas and scenes which blew out of my mind, so that my lips seemed syllabling of their own accord as I walked. What blew the bubbles? Why then? I have no notion. But I wrote the book very quickly; and when it was written, I ceased to be obsessed by my mother. I no longer hear her voice; I do not see her. (81)

However the evidence of the auto/biography contradicts her assertion. Her mother's death is the wound at the center of her life, and her narrative is "built" around it as a house surrounds and contains memories of experiences.

Sara Suleri, *Meatless Days*

Sara Suleri published her autobiography, *Meatless Days*, in 1989. She lived, as a child, in Pakistan. Her father, a political journalist, was an

active participant in the struggle for Pakistan's independence. Her mother, Welsh-born, was a college teacher. Suleri is currently a professor of English at Yale University. Why compare this contemporary, postcolonial text to Woolf's memoir of her life at the center of the Bloomsbury circle, in England, in the early years of this century?

There are relatively superficial similarities in the two auto/biographical narratives and in the connected lives of the pairs of mother/daughter subjects. There are echoes of Woolf's text of mother loss and, subsequent, sister loss in Suleri's text. Also, Woolf's and Suleri's family backgrounds both included class and educational privilege. In fact both families were highly educated and literate. In each text there are descriptions of the "inaccessibility" of the mother in life. Like Julia Stephen and Mrs. Ramsey, in *To the Lighthouse,* Suleri's mother seemed inaccessible to each of her children, individually, because of the crush of their demands, as a group of siblings, and the demands of a patriarchal husband and father. In addition to these distancing aspects of her life in common with Stephen, Suleri's mother remained in the position of a visitor, a noncitizen in Pakistan, the country of her husband and children. Her mother, she writes, learned "the way of walking with tact on other people's land," but she was only a guest, "living in a resident culture that would not tell her its rules" and whose languages surrounded her "like a living space." She seemed like a guest even in her daughter's life, since this daughter was a Pakistani citizen, who spoke Urdu, a language that remained "a shyness on her [mother's] tongue" (163–64, 10). The effect of this "lightness" and lack of permanence on Suleri's narrative is an echo of a similar effect in Woolf's. This near loss, this not quite having enough, of the mother, even in life, and, then, completely after her death, is the central narrative element in both texts.

But Suleri's text does more than echo Woolf's in the details of both life and narrative. Woolf's autobiography and her autobiographical fiction can be seen as an intertext for *Meatless Days.* Suleri's text overtly pairs Woolf's texts and her own. In a conversation with her sister, for example, she humorously compares her own auto/biographical narrative with *To the Lighthouse:* "Last summer my sister Nuz turned to me and said, 'Mair was *To the Lighthouse* for me—she was Mrs. Ramsey.' . . . I smiled at her analogy, which pleased me, but told her that somehow I would say my mother was more invisible, more difficult to discern" (153–54).

The necessity of a second voice to engage in dialogue, to create meaning, in a Bakhtinian sense, is explicitly stated in Suleri's text. Her narrative falls apart without her mother being there to *talk* to. "Mamma," Suleri writes, is "that haunting word at which narrative falls apart" (157). As in Woolf's text, Suleri's voice and her mother's, taken from memory, speak in a dialogue, in which the topic is often the house, the intimate and protected space that "housed" childhood memories.

Metaphors of space, architectural and geographic, are very important in Suleri's text, as in Woolf's. The conversation in her text, between daughter and mother, is one of rooms and buildings, some houses, some not, and, also, geographic sites. However, in Suleri's text the house space is only one of the several types of architectural structures referred to in images. Suleri's buildings are also more often described from the outside rather than from the inside, when compared to those in Woolf's text. Even when she, as the autobiographical subject, speaks from "inside," she narrates from within a house, in Pakistan, with a courtyard, which is an "outside" element within the shelter of the house. This domestic space has margins and borders in its design. Suleri's description of the experience of living in such a house is positive however. She recalls the impossibility of explaining to a friend "the lambent quality of the periphery, its curious sense of space" (106). The notion of inside as shelter is also problematized by her narration of her experience of living in such a space and sleeping in the courtyard during the summer months of her childhood: "I still miss it, the necessity of openness that puts a courtyard in the middle of the house and makes rooms curl around it, so that each bedroom is but a door away from the seclusion of the sky. In summers, too, we slept beneath the stars" (174). The differences in climate between Pakistan and England create very different cultural experiences of houses as shelter as Suleri's text describes.

In addition, Suleri does not write with the same sense of ease of belonging "inside" that Woolf does, because her family lived in many different homes in both England and Pakistan. Her father's career and the political events in Pakistan caused them to leave many houses. Woolf's family very much belonged inside the house and the world she inhabits.[5]

There are, of course, other more important differences between the two texts. Specific geographical locations or "positions" and a narrative subject who lives in several countries and speaks several languages mark Suleri's postcolonial text. In her essay, "Assembling Ingredients: Subjectivity in *Meatless Days,*" Linda Warley describes Suleri's voice in her text as a

> hybrid—a heterogenous unintegrated mix of different cultures that dialectally inform one another. Sara is not Pakistani or British or American. She is none of these and she is all of these. She has "ambidextrous eyes." . . . Her place is somewhere in between geographical locations. (118)

As a postcolonial woman, her subject position is always intrinsically on borders and margins even in her father's country. Warley writes: "If the notion of identity is a problematic one for all autobiographers, it is perhaps the obsession of post-colonial autobiographers" (107). Warley discusses the narrator of *Meatless Days* as doubly marginalized as a postco-

lonial subject and as a woman in hegemonic discourses of the West. In particular, such a subject cannot securely claim any geographical space as a basis for identity. She continues: "[U]nable to repossess original, pre-contact subjective spaces, the contemporary post-colonial subject exists in an ambivalent, polyvalent space that is difficult to secure" (110). Thus, for Suleri, it is impossible to secure her identity to precolonial Pakistan. It no longer exists. Further, she is only part Pakistani. Her mother was born in Wales. However the text contains no descriptions of her mother's childhood. She writes only that her mother was living in London when she met Suleri's father and that they lived together there for several years. Suleri conflates her mother's Welshness with what she calls her "English-ness." To her daughter and her Pakistani family and neighbors she is a representative of the "English" colonial presence. Suleri asks: "What could that world do with a woman who called herself a Pakistani but who looked suspiciously like the past it sought to forget?" (164). She expresses an anger at her mother's easy assumption of Pakistani citizenship despite her "race," which is the race of the colonizer. She describes this anger:

> Did she really think that she could assume the burden of empire, that if she let my father colonize her body and her name she would per-form some slight reparation for the race from which she came? Could she not see that his desire for her was quickened with empire's ghosts, that his need to possess was a clear index of how he was still pos-sessed? (163)

Sara Suleri also lived part of her childhood in England and moved to the United States as a young adult. There is not a precise or single geo-graphic space she can identify with. There are many spaces and positions, and also there are none. Her text, thus, contains images of space that describe a life lived between geographic locations. These images of space also allow her to convey memories associated with the loss of her mother. Throughout, experiences of place and language overlap, as in the follow-ing passage:

> I used to think that our sense of place would be the first to go, after the hurly-burly of our childhood's constant movement. . . . [I]t is still difficult to think of Ifat without remembering her peculiar con-gruence with Lahore, a place that gave her pleasure. "It's blossom-time and nargis-time," she wrote to me in her last letter, "and what a lovely city it is—a veritable garden." . . . When policemen came to take that sentence from me, I darkly knew that my task of reclama-tion would keep me working for some time to come, and that by the time I got them back, those words would be my home. And not just my residence: I made a city of that sentence, laying it out like an architect. (181–82)

Language and place are also entwined in the text when she attempts to bring her parents together in a room: "My plot feels most dangerous to me when I think of bringing them together." She describes their relationship as an association between two discourses or as an unequal marriage of two persons who were rhetorically very different: "the two of them, always startling each other with the difference of their speech." But most significantly, in a spatial sense, the imagined meeting is in his room, and she is described as being surrounded: "Papa's powerful discourse would surround her night and day—when I see her in his room, she is always looking down, gravely listening!" (157).

And, in yet another example, Suleri describes the state of being bilingual as inhabiting more than one space. In her case, as in many others, the two languages represent two different countries, two very different spatial experiences. Such a condition is most often described geographically, that is, two languages are part of a life lived in two or more countries. But she describes her bilingual experience as one situated in two domestic spaces or houses. She writes:

> Speaking two languages may seem a relative affluence, but more often it entails the problems of maintaining a second establishment. . . . When I return to Urdu, I feel shocked at my own neglect of a space so intimate to me: like relearning the proportions of a once-familiar room. . . . (177)

Language, in this text, is space and about space. It also "writes" space for Suleri. Her narrative is about a spatial perception of speech and language, in part. She visualizes her bilingualness and uses images of space, especially domestic space, to describe language and the life associated with language.

Her "plot" or story, Suleri writes, cannot exist outside of a dialogue and connection with her mother. Yet, she also describes her mother's attempts to pull away from the burden of this connection:

> I can feel her spirit shake its head to tell me, "Daughter, unplot yourself; let be." But I could not help the manner in which my day was narrative. . . . Like the secluded hours of afternoon, my mother would retract and disappear, leaving my story suspended until she re-emerged. I think it was a burden to her to be so central to that tale. (156–57)

In this passage, her relationship with her mother is actually described as a narrative or a text. In fact, both Suleri and her mother use literary "language" and terminology to talk about this perceived overlap of their stories and their lived existences. There is clearly an awareness by the mother that their auto/biography is an overlap of narratives. To the mother, her daughter's "plot," which is the story of a childhood mother/daughter

closeness, needs to end; the daughter needs to seek an independent "tale." The mother wants to free herself from this joined story, but her daughter fears that she will not have a "story" or a life without her mother's presence as a subject who is "central to the tale." Life is narrative in this dialogue, and both center on descriptions of space, inside and outside the house. Even the concept of center is also spatial. She fears the empty space or the intrusion of "outside" in her intimate domestic space, a void that would mirror the design of her Pakistani house with the courtyard at its center. The courtyard space also locates additional margins within the house and interrupts the sheltered space.

In addition to the dialogue with her mother, which is the "core of my book," Suleri describes other times in her life, in other locations, also, using architectural images. For example, in one section of her narrative, which is a series of discrete essay-like chapters, she recalls an important relationship with a man named Tom who "made things," including buildings. Within the life of constant geographical and linguistic changes she narrates, the attraction for the permanence of "bricks and mortar" drove this relationship, particularly during the short time they lived together. She writes of this architectural phenomenon and, also, of her frustration in recognizing its falseness as protection or stability:

> During that era he was building a building, and the bricks and mortar of it all absorbed us both. . . . In the careless way that can overtake intimates, we used that building as a unit of time, an ordering principle whose completion would allow us to think of all the different orders that we really ought to construct, as though it could make our decisions for us. Here is where I fault myself, for my lazy trick of deferral that allowed me to believe I could actually locate my own framework in someone else's building. . . . But before I could quite articulate what was happening, the building opened only into more of itself, until what I had assumed was solidity turned out to be its opposite, a structure based on the brittle promise of how much bigger it was still to become. (78–79)

Life and building are interchangeable, here. The building of a structure and its construction schedule becomes a time-keeping presence. When she writes "someone else's building," she implies someone else's life. Psychological knowledge of Suleri's narrative subject, her autobiographical "I," is interchangeable with a knowledge of the sites of the experiences that formed the subject's psychology, in a Bachelardian sense. Bachelard also insists that the imagination is not capable of remembering duration or the passage of time. One can only have memories of the spaces where experiences occur. When Suleri writes that her emotional carelessness allowed her "to believe I could actually locate my own frame in someone else's building," she is using a Bachelardian approach to human psychol-

ogy. She is saying that she can understand her experience if she understands the building it is attached to or is experienced in.

Finally, I have already discussed the courtyard at the center of the home of her childhood as an upperclass Pakistani, but I need to say more about this architectural feature of the house. Her Pakistani house/structure has a hole at its center, an opening to the outside world and to natural elements. Suleri uses this courtyard image in describing her relationship and conversations with her mother. But was this empty center a place first, or was it a psychological state attached to a place? Suleri writes: "Mamma pain suggests the immorality of absence" (173). Her text is, in part, an exploration of the immorality of this absence from a specific location that was a house in Pakistan built with absence, a courtyard, at its center: "the necessity of openness that puts a courtyard in the middle of a house and makes rooms curl around it . . ." (175). The location was also the country of Pakistan and the continent of Asia. Her childhood, along with its intimate spaces, is also located, is housed, and, with the death of her mother, becomes a located structure with an empty core. Suleri writes indirectly, only, of her anger at her mother's perceived tendency to slip away and leave her daughter, even in life. Sometimes, very briefly, she does accuse her mother of a selfish lack of commitment to staying in the house and location of her children. She writes: "[S]he certainly appeared to suggest that the possibility of adding herself to anything was irrelevant to her. By the same token she did not fear subtraction" (165).

The poetics and structure of her text, like Woolf's, are elements of an "aesthetic form which is structured around an absence" (Anderson 69). To summarize, the elements of this aesthetic structure include a circular pattern of time that loops the text back, repeatedly, to the date of her mother's death; the placement of the narrative is most often in her childhood home, and qualities of the house, which are conventionally maternal, predominate; the narrative is sometimes elegiac in tone. For example, Suleri abruptly interrupts the narrative with statements, such as: "Have I mentioned that I loved her face?" (167). This statement of love is notable also because it is one of very few descriptions of her mother's body and of the daughter's connection to this body. There is a funereal quality to this avowal of love at a distance, however, as if the speaker is honoring her mother's memory after her mother's life is over.

Bachelard described intimate spaces using maternal and protective images. In both autobiographies, loss of a living maternal figure accompanies the predominance of particular spatial images. However, there are important differences in the types of spatial images in these texts, as I have stated. Woolf's are almost always images of home and are very specific. It is not hard for the reader to form a mental picture of the houses of her childhood. Furniture, architectural details—windows, ledges—and ma-

jor divisions in the uses of the space are described. The conversation that runs through Suleri's text is more abstract. Her homes are not revealed in much detail. We only know that the Pakistani home had a courtyard. Instead, her spatial vocabulary contains words such as "establishment," "residence," "city," "building," and "bricks." She seems to talk more of travel, sometimes transcontinental, that separates her houses and buildings, the sites of her memories.

Thus, both Woolf and Suleri present their auto/biographical texts with spatial images. Bachelard's theory of psychoanalysis privileges the spaces and, in particular, the houses that are the setting for memories of experiences. Both authors' mothers were dead at the time when they wrote their texts. For Woolf, especially, the memories are distant ones, since she was so young when her mother died. Therefore the spatial images that accompany memories may dominate in their texts. These are especially "lifeless" texts. Brick and mortar predominate along with intellectual perceptions about the connections between language and space. The texts do not contain the bodies of either the mothers or daughters. The intimacies and physical details of shared experiences of the body are noticeably absent. Death and absence of the maternal body leaves these daughters with a loss of the touch and feel of a woman's body. And well before their deaths, these women are distant and very likely to "slip away."

As I have stated, the empty center of both texts is associated with a nonlinear structure in which the narrative repeatedly returns, chronologically, to the date of the mother's death. This circling round and round a wound and a loss follows a pattern that resembles the building of a nest. A nest is a house-like structure that can nurture young. A female bird deposits her eggs in a tightly built nest of entwined sticks. As the eggs mature, the mother's body and its warmth completes the enclosed protective environment that allows life to "begin well." As Bachelard writes, "[Life] begins enclosed, protected, all warm in the bosom of the house" (8). But without the "Mamma," which is "that haunting word at which narrative falls apart," the house becomes the only maternal presence in the life and texts of Virginia Woolf and Sara Suleri. Both writers also describe unfulfilled yearnings for their mothers even before their deaths. Suleri describes her desire for the intimacy of sound and touch with her mother. She writes: "I would not wake to the sound of my mother calling my name but instead to the sound of her privacy with some piece of music, her singing to it rather than to me" (161).

In the following chapter, I discuss texts that contain dialogues about intimacy and warmth between the bodies of mother and daughter. These texts provide a contrast to two texts in which the furnishings and walls of house and home dominate the "conversations" between Virginia Woolf and her mother and between Sara Suleri and her mother.

My Own House

[I]t is just the way rooms open into each other that is one of
the charms of the house, a seduction that can only be felt when
one is alone here. People often imagine that I must be lonely.
How can I explain? I want to say,"Oh no! You see the house
is with me." And it is with me in this particular way, as both
a demand and a support, only when I am alone here.
 —May Sarton, *Plant Dreaming Deep*

I have two administrative positions on a university campus partly because
there have been so many losses of budget dollars and positions. Also, I
have chosen this dual career as the only way to become involved in larger
challenges and opportunities at a time when there is very little hiring of
administrators.

In one position I am a project director for a grant supported program
that provides a service to the community. I supervise five employees in
this position: four professionals (counselors) and one secretarial worker.
All are women, and several are longtime coworkers.

I was sitting at my desk—in my project director's office—last week,
when one of my staff, a counselor who has worked with me for seven
years, walked into the doorway of my office and asked me a question.
After receiving a brief answer, she said, "You've changed." Intrigued and
curious, I responded: "Is it a good change? When did this change start
to happen?" Very promptly, she said, "Oh it's definitely a good change.
Working with you has become more and more of a pleasure. I think it
started when you bought the house."

Two years ago, at the age of fifty-three, I became a home owner for
the first time. This is my first house as well as the first time I have not
been a tenant since I left my parents' home at age twenty-one. Through
a marriage and several other partnerships, I have lived, with children and
without, in rented apartments. Feeling financially courageous, yet very
fearful, I began looking at houses almost three years ago. My initial rea-
son for house hunting was my landlord's announcement that he was sell-
ing the two-family house I had lived in comfortably and very cheaply for
almost twenty years. Because my major income had come and still comes
from a grant, I was cautious and very careful not to obligate myself fi-
nancially. However, I became more daring in spite of this and, encour-
aged by very low prices on real estate in my town, began exploring houses
for sale. I formed a relationship with a real estate agent, not really un-
derstanding the rules of this partnership. She took me to see many houses
in my price range (under seventy-thousand dollars). All were disappoint-
ing and felt like someone else's house. Finally, as a favor to an old friend,
I agreed to call another agent, who needed help in getting started in the real
estate business. She showed me only one house, and I fell in love with it.

Through the whole dance and ritual that leads to a "closing," I vacil-lated between euphoria and full panic attacks. What helped soothe the fears was the seller, a senior professor of anthropology on my campus whom I respected for her intelligence and the beautiful work she had done on the house. This was an intimate relationship because it was she who had created the spaces I would inhabit. I admired her taste in colors, pat-terns, and wood finishes and have changed very little in the house since I moved in.

What has surprised me about the experience of buying my house, moving in, and now happily occupying it is how profound the effect has been on me. My employee was right. I've changed. Unlike some of life's major milestones and experiences that have been less wonderful than I expected, this one has shocked me because I could not possibly have ex-pected so much from it. I am "in love" with my beautiful house. I savor the sense of possession and utter privacy it gives me. The house grace-fully reflects my aesthetic tastes and the value I place on architectural integrity. But there is more. Home ownership is an incredibly empower-ing experience for me as a woman, a single woman. Still, today, very few single women, especially those of my age, buy their own houses.

I don't perceive that I have made my house into a maternal presence to the extent that Woolf and Suleri did, in their texts. There is a huge difference between my life experience and that of women who have lost their mothers at a young age. My mother is still living, but at a distance. Perhaps, though, since I have lived so far from her for thirty years, I had cultivated self-nurturing even before I bought my house. Thus, my house is my partner, my lover, my newly acquired second skin, as well as a motherly presence.

My house is, in addition, a lovely piece of tangible beauty that enriches my life. Everywhere the rooms contain calm, orderly, white space. I have placed every object so as to delight my eye. The house was built in 1917 in a style called Arts and Crafts, Craftsman, or bungalow. I admire this twentieth-century architecture as I loved the early houses in New England when I lived there. I feel extremely comfortable with all the wood trim, columns, and built in storage, the elegant but simple leaded-glass win-dows and original light fixtures.

Having the responsibility of a house, alone, was something I feared. What I did not foresee was the pleasure I would derive from this happy burden that I now carry along with the joy of sole ownership. Also, I take pride in the fact that I earned all the money myself for this purchase. I feel professionally and fiscally competent as well as aesthetically privi-leged every time I turn the key in the lock.

I have let myself love solitude in this house. All my life it has attracted me, but I lived among others. When all full-time living relationships ended for me, I was at first lonely but slowly delighted with the experience.

33

Owning my own house has given me what Virginia Woolf needed, a room of my own, in fact, many rooms. I love the privacy and the peace in my own house, alone, after my long days with people in my two offices. In addition, after work, I dance and exercise in groups at least three times every week. When I return home, I'm so comforted by the quiet and the visual peace. Yet there is no lack in this solitude. The presence of the house is with me. And, as May Sarton described in *Plant Dreaming Deep*, my house is a lovely place to welcome guests into for short stays, but "I have known from the beginning that the true presence of the house can be felt only when one is alone here . . ." (154).

If, as Bachelard theorized, human beings need enclosed space for shelter and protection of the imagination as well as the body, then my imagination now has a delightfully large and beautiful space in which to be sheltered. It/I have been nourished and stimulated as well. I have changed. Even my reading has changed. I am so pleased with this new solitude that I am reading, especially women's autobiographical texts written during a solitary time in the writers' lives, whether temporary or more permanent. The texts I choose to read also tend to be written by "older women," those in their fifties, sixties, and seventies.[6] Maybe this pleasure requires the attainment of a certain age to be appreciated. Or maybe their lives, like mine, were filled with others when they were younger.

This is a time, for me, when the issues of house/home, solitude, work, and aging are constantly in my thoughts. New insights and an awareness of new pleasures bounce around in my head about these issues and my own experiences. I often think of May Sarton's words from *At Seventy*: "I felt at home in the silent house. I felt at home with myself" (131).

3

Conversations about Intimacy, Bodies, and Sexuality

I saw my own mother's menstrual blood before I saw my own.
Hers was the first female body I ever looked at, to know what
women were, what I was to be. I remember taking baths with
her in the hot summers of early childhood, playing with her
in the cool water. . . . In early adolescence I still glanced slyly
at my mother's body, vaguely imagining: I too shall have
breasts, full hips, hair between my thighs.
 —Adrienne Rich, *Of Woman Born*

What kind of a lover have you made me, mother
who drew me into bed with you at six/at sixteen
oh, even at sixty-six you do still
lifting up the blanket with one arm
lining out the space for my body with the other

 as if our bodies still beat
 inside the same skin
 as if you never noticed
 when they cut me
 out
 from you.
 —Cherríe Moraga, "La Dulce Culpa"

In contrast to autobiographies that link embedded maternal narratives
to considerations of buildings and architectural space, the texts I discuss
in this chapter all contain "dialogues" about intimacy and bodies, spe-
cifically about the bodies of a daughter and a mother. All the "conversa-
tions" between the voices of mother and daughter in these texts have some
similar images. Bathing, grooming, and bed-sharing are talked about, al-
though sometimes with stated reticence. I discuss these conversations
about intimacy, sexuality, and women's bodies and focus on these images
in Adrienne Rich's *Of Woman Born: Motherhood as Experience and
Institution,* Cherríe Moraga's *Loving in the War Years: lo que nunca pasó*

por sus labios, Joan Nestle's *A Restricted Country,* and Audre Lorde's *Zami: A New Spelling of My Name: A Biomythography.*

In each of these daughters' texts, the writer connects lesbian sexuality with her relationship with her mother. Adrienne Rich cites the poet Sue Silvermarie, who writes personally about her perception of the overlap of the two relationships. Silvermarie writes: "I find now, instead of a contradiction between lesbian and mother, there is an overlapping. . . . Now I am ready to go back and understand the one whose body actually carried me. . . . I could never want her until I myself had been wanted. By a woman" (26–27). Some of these four daughters who write of such an overlap, however, see their lesbian relationships as an extension of the relationships with their mothers. That is, the bond with the mother and her body came first, and sexual love for women originates in a love for the mother. However, it is the rhetorical and discursive effects of this overlap of daughter's and mother's texts, their interconnectedness, that I will focus on in this group of texts in which sexuality is both lesbian and maternal.

Each of the autobiographers whose texts are grouped here sometimes uses a rhetoric that is erotic. At the same time, this rhetoric is tied to an emancipatory feminist political agenda. All of these texts were written by lesbian feminist writers in the 1970s and 1980s. Rich published her text first in 1976. Her revision and the other texts were written from 1983 to 1987. Rich's early text is, thus, an intertext for the others. Each woman/daughter speaks from a subject position that is her identity "politics" and her sexuality. In "Unspeakable Differences," Julia Watson argues that each of these autobiographies of the 1970s and 1980s may be grouped with other "personal, intimate narratives that locate sexuality as not just a construct but [as] a revising of an identity" (157). Watson's premise is that within a patriarchal tradition woman is presumed to voice a heterosexual sexuality when she speaks autobiographically. When lesbian sexuality is spoken, the naming of an unspeakable identity creates new subjects and also serves as a basis for a specific political vision. Sidonie Smith calls these texts "self-consciously political autobiographical acts," or "autobiographical manifestos." As such, each insists on "identity in service to an emancipatory politics" ("Autobiographical Manifesto" 189). In such texts, she states, the autobiographer adopts a rhetoric grounded in the erotics of the body and also attached to a political agenda.

Female group identification, through a rhetorical appeal to the female body as a site of multiple commonalities, is also used as a political source of identity in these texts. Each autobiographer engages in a conversation about the intimate details of the lives of women. Rita Felski focuses on such texts when she discusses the feminist "confession." She links the importance of this subgenre in autobiography to the model of conscious-

ness-raising that uses personal disclosure to achieve political awareness and subsequent action. As she states: "[F]eminist confessional literature . . . explicitly seeks to disclose the most intimate and often traumatic details of the author's life and to elucidate their broader implications" (88). Feminist confession tends to emphasize the more private and everyday experiences of women, which can also be "traumatic," such as domestic violence or pregnancy "scares." These narratives often include descriptions of physical details of female bodies that "bind women together" (94). Thus a communal identity rather than an emphasis on individual traits predominates in such texts. These auto/biographical narratives are grounded in a relationship of subjects with bodies that share a gender. As Smith states, "[G]roup identification . . . is the rhetorical ground of appeal" (193). In unique ways, each text is a manifesto that uses lesbian identity and the commonality of female bodies to put forward a political agenda of liberation.

These conversations are also rhetorical gestures to the female reader that attempt to establish trust and to overcome the fragmentary effect of the extreme specificity that is always present in an autobiography. Felski notes that these texts, as feminist confessions, also include the reader in an intimacy that assumes a sharing of common experiences, many of which are sited in the body.[1] She describes a sense of "communality" that is achieved or at least attempted through a "tone of intimacy, shared allusions, and unexplained references" that the reader is assumed to be familiar with (99).

Feminist confessional texts are often structured through the use of an organizing principle based on the experiences of the subject rather than chronological time and events. Felski notes that the structure of the confession is "episodic and fragmented, not chronological and linear" (99). All of the following daughter/writers organize their texts around experiences, often intimate experiences with their mothers. All of their texts combine genres in addition to auto/biography. Poetry, history, political analysis, and folk tales are freely used. Moraga's text also combines two languages and attempts to include the reader in the bilingual condition of her "dialogue" with her mother.

Adrienne Rich, *Of Woman Born*

Adrienne Rich published *Of Woman Born: Motherhood as Experience and Institution* in 1976; ten years later she issued a Tenth Anniversary Edition. Her autobiography, she stated, was an attempt to create a non-linear, multi-voiced textual collage. Personal recollections, political analysis, history, myth, and poetry are combined throughout the text. In the new introduction and in additional footnotes, she acknowledges limita-

tions of her own theory. She admits to her use of her personal experience to construct a "universal" politics of motherhood. In this later edition, she writes from an awareness that her "personal" is a unique experience rather than a common one. Her subjectivity is based or "sited" in the specifics of her white, middle-class, educated, and lesbian life.

Still, in an attempt to generalize her unique experience somewhat and to include the reader, Rich uses many of the techniques of feminist confession. She shares intimate details of the body, especially those associated with motherhood and reproduction, including menstruation, childbirth, and breast-feeding. Rich's chapter "Motherhood and Daughterhood" is, first, about an "embodied" relationship, one that she describes physically and physiologically. She enters this chapter, which, she states, is "the core of my book, . . . as a woman . . . born between her mother's legs" (218). She then narrates a recollection of her mother that is centered in images of the fluids of menstrual blood and shared bath water. In this passage, Rich ties her awareness of what her body is to become to the sight/site of her mother's body:

> I saw my own mother's menstrual blood before I saw my own. Hers was the first female body I ever looked at, to know what women were, what I was to be. I remember taking baths with her in the hot summers of early childhood, playing with her in the cool water In early adolescence I still glanced slyly at my mother's body, vaguely imagining: I too shall have breasts, full hips, hair between my thighs. (218)

She places her subject position and her mother's, in this passage and throughout the text, in the body, using detailed and intimate images. The image of a shared bath brings together remembrances of shared nudity and of menstruation. The menstrual blood is "seen" and revealed, rather than hidden away, in this intimate memory. There are, however, three memories here. The one in early childhood is in the bath. The glances at her mother's adult body occurred in early adolescence. The sight of her mother's menstrual blood is not fully remembered or described. It is only briefly mentioned, yet it clearly was significant to Rich. This pattern of nonchronological groupings of intimate images often occurs in her text. As in other confessional texts, some of the memories and images center on major, sometimes traumatic experiences.

Throughout this core chapter, Rich also contrasts her father's disdain for the "impurity" and "messiness" of the female body, in its menstrual and birthing functions, with an acceptance and self-love that she derived from the intense pleasure she experienced while viewing her mother's body. She describes her father's relation to female beauty and body, as she remembers feeling it during her childhood:

My father talked a great deal of beauty and the need for perfection. He felt the female body to be impure; he did not like its natural smells. His incorporeality was a way of disengaging himself from that lower realm where women sweated, excreted, grew bloody every month, became pregnant. (My mother became aware, in the last months of pregnancy, that he always looked away from her body.) (220)

She contrasts counter images that she took from her adolescent "love affair" with the look of her mother's body, a love affair that sustained her through a long period of intellectual identification with her father. Rich writes:

[T]he early pleasure and reassurance I found in my mother's body was, I believe, an imprinting never to be wholly erased, even in those years when, as my father's daughter, I suffered the obscure bodily self-hatred peculiar to women who view themselves through the eyes of men. . . . I cannot help but feel that I finally came to love my own body through first having loved hers [her mother's], that this was a profound matrilineal bequest. I knew I was not an incorporeal intellect. (220)

At the same time, the desire for a femaleness that is different from her mother's is very insistent in Rich's text. She describes angry feelings she had as an adolescent alongside her physical longings for her mother's voluptuous body. Even as she describes the desirable fullness of her mother's body, she angrily asserts:

I too shall have breasts, full hips, hair between my thighs—whatever that meant to me then, and with all the ambivalence of such a thought. And there were other thoughts: I too shall marry, have children— but *not like her*, I shall find a way of doing it differently. (219)

She tells of an uncomfortable ambivalence toward her mother that does not seem to end, even with the mother's death. She reveals the painful difficulty that accompanies her attempt to write about her mother and, especially, to incorporate this ambivalence into her narrative. There is no sense of resolution in the text: "I struggle to describe what it felt like to be her daughter. . . . I find myself divided, slipping under her skin; a part of me identifies too much with her. I know deep reservoirs of anger toward her still exist" (223–24).

The most telling and painful glimpse of the pain of this daughter's angry connection to her mother is the four lines of a Susan Griffin poem that begin Rich's core chapter:

Mother
I write home
I am alone and
give me my body back.

The speaker is angry at the recognition of a body shared with her mother. It is not clear whether she wants independence from her mother, who possessed her body before birth, or whether she doesn't want to be like her mother, in body. Yet, she writes home, and she is alone. It is an anguished expression of ambivalence by a daughter toward her mother.

In Rich's text, her mother's voice and text are intimately joined with hers, as their bodies are joined through imagery. Both voices are always present in a relationship that resembles dialogue. As Bakhtin states: "The word in language is half someone else's[,] . . . and the boundaries between the two are at first scarcely perceptible" (*Dialogic* 293, 345n). Rich's fear of the overlap is revealed in her core chapter.

Rich's chapter "Motherhood and Daughterhood" was the mother text or mother lode of *my* interest in this alternative genre, this auto/biography of daughter and mother in which the maternal narrative forms the "core" of the daughter's text. However, what surprises me, with every rereading, is the brevity of the mother's narrative in this core chapter. Seven pages within a volume of 322 pages summarily chronicle Rich's own version of "the great unwritten story." The outlines of her mother's life are here, but the "great cathexis and passion" are touched upon and then retreated from (*Of Woman* 225). Instead, the impersonal voice of Rich, as theoretician and historian, dominates the chapter.

Rich's text, through its silences and gaps, reveals her extreme difficulty in approaching the maternal narrative. She writes openly and passionately of a multitude of human attachments and desires. However, the enormity of the connection to her own mother seems to be too frightening or ambivalent to approach more than briefly. As an example, she describes an intense, but unspoken, longing for her mother after the birth of her first child:

> When my first child was born, I was barely in communication with my parents. . . . Emerging from the fear, exhaustion, and alienation of my first childbirth, I could not admit even to myself that I wanted my mother, let alone tell her how much I wanted her. When she visited me in the hospital neither of us could uncoil the obscure lashings of feeling that darkened the room, the tangled thread running backward to where she had labored for three days to give birth to me. . . . (222)

Rich reveals deep anger at her mother for "leaving her" emotionally to deal with the pain of birth alone. However, it is she who has pulled away from communication with her mother. She desires her mother and at the same time fears closeness to a person she shares such an intense bond with. This is the same pattern that the narrative follows. She writes earlier: "I still feel the anger of a daughter, pregnant, wanting my mother

desperately and feeling she had gone over to the enemy" (224). Sometimes she blames her father for dividing them and her mother for choosing the bond with her husband over the bond with her daughter. Mostly, she does not place blame but accepts the loss as an inevitability. The "tangled thread" cannot be uncoiled. The "obscure lashings of feeling" will remain in the room, but mother and daughter will not speak their desire.

Rich's tortured attempts to "uncoil the obscure lashings of feeling that darkened the room" mark the entire "core" chapter in *Of Woman Born*. There is a repetitive pattern of erotic and intimate images followed by hasty "retreats" into more impersonal rhetoric. The tactile and sensuous details in the description of her mother's body, with its menstrual and reproductive juices, are so potent in Rich's text that it is only after many readings that the brevity of her description of her mother is also realized. There is much silence in the engagement of mother's and daughter's narratives in Rich's auto/biography. In the midst of this pervasive silence, the maternal biography is explosive in this text; it "breaks open" the autobiography, briefly.

Throughout the chapter, also, both desire and anger pervade Rich's attempt to converse with her mother. The chapter commences with the autobiographical subject attempting to begin her most difficult textual task as she describes its parameters:

> A folder lies open beside me as I start to write, spilling out references and quotations, all relevant probably, but none of which can help me to begin. This is the core of my book, and I enter it as a woman who, born between her mother's legs, has time after time and in different ways tried to return to her mother, to repossess her and be repossessed by her, to find the mutual confirmation from and with another woman that daughters and mothers alike hunger for, pull away from, make possible or impossible for each other. (218)

The daughter's voice in the text continues to "hunger for, pull away from" a dialogue with the mother's voice. The short passages of connection reveal very powerful emotions that lie beneath the ruptures in the text. The mother is "the whole world," and "the first female body I ever looked at, to know what women were, what I was to be." She is also the other, the stunted victim of patriarchy: "And there were other thoughts . . . but *not like her*. I shall find a way of doing it all differently" (218–19). Indeed, this anger is focused on her frustration in not being able to *talk* to her mother. It is the "silence" between them rather than open and intimate dialogue that is revealed and sadly accepted.

In conclusion, Rich's chapter "Motherhood and Daughterhood" is a writing of an immense tangle of feelings. The "dialogue" with her mother is about both intimacy and angry distance. It is also about a daughter's

difficulty in beginning and continuing this dialogue. Rich makes an impassioned start but finally cannot write much of her mother's biographical narrative. Most of the chapter she calls the "core" of her book is about other mothers and other daughters. The language in most of the chapter, particularly the second section, is abstract, and the pronouns are impersonal. In her theoretical voice, she concludes:

> The loss of the daughter to the mother, the mother to the daughter, is the essential female tragedy. We acknowledge Lear (father-daughter split), Hamlet (son and mother), and Oedipus (son and mother) as great embodiments of the human tragedy; but there is no presently enduring recognition of mother-daughter passion and rupture. (237)

Rich reveals an awareness of her frustrated loss of dialogue and relationship and a recognition that the brevity of her mother's narrative provides a hesitant almost mute testimony to her conflicted desires. Perhaps the saddest words she writes about her mother describe her acceptance of this lack of communication between them:

> I no longer have fantasies . . . of some infinitely healing conversation with her, in which we could show all our wounds, transcend the pain we have shared as mother and daughter, say everything at last. But in writing these pages, I am admitting, at least, how important her existence is and has been for me. (224)

Cherríe Moraga, *Loving in the War Years: lo que nunca pasó por sus labios*

Cherríe Moraga's text, in contrast to Rich's, is a "love letter." She places her mother and their bilingual conversation at the center of her autobiographical text, which is passionate, intimate, yet political, at the same time. Like Rich's, Moraga's structure is experimental and nonlinear. The text is the result of a decade of writing and includes short fiction, poetry, and testimonial essays in English and Spanish. The autobiographical "I" of Moraga's text speaks with a political voice, as it does in Rich's. Nancy Saporta Sternbach, in her essay "'A Deep Racial Memory of Love': The Chicana Feminism of Cherríe Moraga," connects Moraga's text to her political agenda, as a Chicana lesbian feminist. Her stated "purpose" for her writing, according to Sternbach, is "not merely artistic and literary, but rather political. . . . Moraga uses the act of writing as a process of concientización in order to reclaim her Chicanismo" (51).

Moraga's writing is bilingual with no gestures to include a reader who is monolingual. The text is written this way as an attempt to reconnect with her mother's "mother tongue." As a Chicana lesbian, she proclaims the familial link to her mother and other female relatives as a political

statement. She has lost the use of her mother's language, Spanish, and is attempting to regain her cultural history by reclaiming the language of her mother. She describes being in the uncomfortable position of having to pay Berlitz for classes in Spanish. She writes in a journal about a phone conversation with the receptionist at Berlitz. It angers her to be *"paying for culture. When I was born between the legs of the best teacher I could have had"* (141). The basis for her attempt at relearning Spanish is a desire to reconnect with her Chicana heritage, but she places this desire in a yearning for connection with her mother. This desire/yearning is often erotically framed and voiced. She writes about the perceived connection between heritage, mother, and sexuality and that all are also connected to language and to writing:

> Re-learning Spanish scares me. I have not spoken much of la lengua here. . . . In returning to the love of my race, I must return to the fact that not only has the mother been taken from me, but her tongue, her mothertongue. I want the language, feel my tongue rise to the occasion of feeling at home, in common. (141)

It is difficult to talk about this passage, as it is the entire text, without talking about many issues at once. She brings together feminist, lesbian, and Chicana liberation politics and erotic poetry and prose. And always she is addressing her text to her mother. She is in dialogue with her mother about language, sexuality, and politics. There is no separation of these issues in Moraga's text.

A central narrative element in this auto/biography is her description of her love for women and, in particular, her mother. Her lesbianism and her maternal love cannot be separated. In fact, she writes that she has always loved women and women's bodies and that her mother was her first "love." She shared her mother's bed and the intimacy of her touch. When she masturbates, as a young girl, in what she calls her "private bathroom ritual," she connects the orgasmic sensations to the sound of her mother's voice. She recalls these experiences:

> [T]he pressure I felt in my bowels, and the heat in my lower back— all commingled into a delicious kind of pleasure. . . . the slightest amount of pressure drew the sensation deep from out of the pit of my stomach and into my vagina in cool streams of relief. If I held my knees together tight enough . . . the feeling would sometimes replay itself in echoes of kindly, calling voices—momma voices. . . . (122–23)

Remembering these earliest sexual experiences, she connects them to her mother and specifically to the sound of her voice. Mother, sexuality, and language come together at this point in her text and at many others. Moraga writes about a sexual desire for women in general, including her mother.

Again the overlap between the two texts and the dialogic engagement of the two voices creates certain discursive effects. The chronology of the text is not linear. All memories are combined around images rather than time lines. However, she situates the time of her awareness of the link between her lesbianism and her desire for intimacy with her mother in adulthood. After separating from her family and living with women, she can now make connections between early and more current awareness. She states directly: "When I finally lifted the lid to my lesbianism, a profound connection with my mother reawakened in me. . . . *Yes, this is why I love women. This woman is my mother. There is no love as strong as this* . . ." (52, 102). Thus, Moraga explicitly connects her love for her mother to her sexual love for women. The dialogue in the text between the voice of the daughter and her mother's voice is sexual and erotic. She speaks directly to her mother in many parts of the text rather than only about her. These moments when she uses the pronoun "you" to address her mother are all in the poetry sections of the text. Also, she narrates conversations between them. She describes one very painful conversation with her mother about her need to move away from her family to gain a sense of autonomy and separation. This is a major break because she is the only person among her relatives "who ever left home for good without getting married first." Her mother warns her that friends cannot replace family and reveals her pain at her daughter's "substitution" of lovers for herself. Moraga writes: "She said, 'No one is ever going to love you as much as I do. No one.' We were both crying by then and I responded, 'I know that. I know. I know how strong your love is. Why do you think I am a lesbian?'" (138). In this passage, it is the reader who is addressed and included in an intimate conversation.

In her introducción, Moraga explicitly combines these images of intimacy and sexuality with her political agenda of liberation. In the first poem, she explains her title: "*We are in love in wartime. . . . [I]t is our being together that makes the pain*" (i). She continues: "Sex has always been part of the question of freedom. The freedom to want passionately. To live it out in the body of the poem, in the body of the woman" (iv–v). She also joins political writing and personal narratives that describe more mundane daily "ailments" that she shares with friends and lovers. In passages such as the following one, the dailiness of a backache and her political engagement with multiple oppressions, as a writer, are connected:

> A friend told me once how no wonder I had called the first book I co-edited (with Gloria Anzuldúa), "This Bridge Called My Back." *You have chronic back trouble*, she says. Funny, I had never considered this most obvious connection, all along my back giving me constant pain. And the spot that hurts the most is the muscle that controls the movement of my fingers and hands while typing. I feel it now straining at my desk. (v)

Throughout her text, Moraga uses not only images of the back but also of the mouth. These images include detailed descriptions of eating, kissing, oral sex, and speaking. Each section in her book is "decorated" or announced with a black and white graphic image of two forks side by side but facing in opposite directions. Forks are utensils for both food and the mouth. They connect the two in the act of eating. The forks in these graphics are side by side but reversed, which puts their "bodies" tightly together.

The mouth images appear in many of the most "political" sections. For example, she writes:

> I cannot stomach the twists sexual repression takes in the Latina. It makes us too-hot-to-handle. Like walking fire hazards, burning bodies in our paths with the singe of our tongues, or the cut of our eyes. Sex turned manipulation, control—which ravages the psyche, rather than satisfy the yearning body and heart. (137)

The singe of the tongue represents an Anglo stereotype of the Latina. The need to repress the hot desires of the Latina woman makes her a sexual body only. She angrily denounces this form of sexual repression that harms all Latina women, but especially lesbians, whose sexuality is portrayed as excessive because of its refusal to conform to heterosexual "normalcy."

Images of mouths and tongues are used to represent the source of language, love, and lust. She recalls a recurring dream of a mouth that is "too big to close" and, thus, uncontrollable: "It will flap in the wind like legs in sex, not driven by the mind." The dream ends with a contrasting image of the mouth as creator and life giver: "*And there is a woman coming out of her mouth. / Hay una mujer que viene de la boca*" (142).

The mouth that speaks and eats is often confused with the "mouth" of the vagina in her images. Sometimes the facial mouth bleeds and gives birth. Or this same mouth is where the threat and fear of rape is felt. She writes: "If they hurt me, they will hurt me in that place. *The place where I open my mouth to kiss and something primordial draws the lips back, cause[s] a woman to defend herself*" (137). Sometimes the vagina speaks. Her images bring together both orifices as indistinguishable openings that take in and give forth at the same time. She concludes her text with a passage in English and Spanish that places both mouth and vagina within the heart, a problematic and haunting view of the indistinguishability of all three organs. Moraga writes (translations are mine): "It's as if la boca [the mouth] were centered on el centro del corazón [in the center of the heart], not in the head at all. The same place where the cunt beats" (142). The speaking of the erotics and the physical siting of the body come together in the mouth.

Adrienne Rich's rhetorical challenge to women writers, to address and amend "the essential female tragedy . . . the loss of the daughter to the

mother, the mother to the daughter," is answered in prose and poetry in Moraga's auto/biographical narrative. She echoes Rich in stating her own resolve and intent for her text: "The secret agenda of denial which has so often turned the relationships between mother and daughter, sister and sister, and compañeros into battlegrounds has got to come to an end" (140). The story of the mother-daughter relationship *is* written in Moraga's text, unlike Rich's, and strongly linked to her love for all women: her grandmother (abuela), aunt (tía) and her lovers, as well as her love for her home, language, and culture. She *talks* intimately and passionately in a dialogue, with her mother's voice, which centers on the erotics of her sexual desire for the female body including her mother's body. The intimacy in her text and in the life she writes about starts with her declaration of love: *"I am my mother's lover"* (32).

Joan Nestle, *A Restricted Country*

Joan Nestle's *A Restricted Country* is a unique auto/biography in many ways. Sexual identity is privileged among Nestle's identities as a Jewish, lesbian, working-class historian, activist, and writer of erotica. Elizabeth Wilson regards Nestle's text as a major success because her auto/biographical writing bridges a particular gap or division that often occurs in self-referential texts. Wilson writes: "There is no division here . . . between the sharp idiosyncratic memories of childhood and the more partisan, polemical experiences of adulthood." Wilson feels that Nestle achieves this by conveying so intensely her conviction that the events in her childhood caused or created her adult politicization and that her present day politics are anchored in her early experience of sexuality and her awareness of her mother's sexuality (112).

At the center of Nestle's text is a "dialogue" between two subjects of two inseparable texts about sexuality and intimacy and, also, the craft of writing. Her voice and her mother's voice talk about liberation, the freedom to express and act upon sexual desire and the more "public" freedom from political oppression. Throughout her text, as Regenia Gagnier comments in her review essay "Feminist Autobiographies in the 1980's," Nestle reclaims the female body from the traditional Cartesian split between "self" and body. Gagnier states: "It [the body in Nestle's text] is not the objectified exterior in which the subjective self cowers. . . . The expression of its materiality defines the self, connects the self to the world, and indeed changes the world" (145).

Nestle states in her preface that she considers her text a history of "a flesh and a spirit" that lived amid the events of the 1950s through those of the 1980s. The events of those years, she says, have especially left marks on her mind and imagination. But it is the "marks" on her body that she

wants to emphasize because such marks have been left out of many auto/ biographies. She writes, "[I]t is the body that has been most often cheated out of its own historical language, the body that so often appears as the ahistorical force that we simply carry with us" (9). The language of the body and its most intimate experiences predominate in her text but are always connected to an agenda of sexual liberation. She embraces the feminist slogan "the personal is political" but believes she must carry it one step further: "[I]f the personal is political, the more personal is historical" (10). Her descriptions are blunt and colloquial. When she describes her mother's body and sexuality, however, acceptance is primary. She portrays her mother's very open enjoyment of "fucking" in her chapter "My Mother Liked to Fuck." She writes: "My mother liked sex and let me know throughout the years both the punishments and the rewards she earned because she dared to be clear about enjoying fucking" (120).

Nestle takes her title from her chapter of the same name. This essay tells the painful story of her first contact with institutionalized anti-Semitism at a ranch resort in Arizona. This is also her first awareness of her mother's inability to "fit" into middle-class, married behavioral norms. As she writes in an earlier chapter, she learned that her mother feared and hated "women who, from the comfort of their marriages called her whore" (88). In this chapter, Nestle, her mother, and brother take a first family vacation and a first trip west of the Mississippi and gingerly enter "the shining new land of the American West" known to them through Western movies and magazine ads (29). Upon their arrival at the ranch resort, they are ushered into a rustic dining room and seated at a "far distance" from the other guests. As the waitress sets the table, she also places a small white card near each place. Nestle relates: "I picked up mine and read, *Because this guest ranch is run like a family, we are restricted to members of the Gentile faith only*" (30). Her mother and the manager later negotiate a transfer to a guest ranch for Jews. The corresponding shock is the experience of seeing that her mother is also exiled in this haven, despite her Jewishness, because she has no husband and no familiarity with the requisite behavior of middle-class family vacations in 1950s heterosexual America. Nestle writes:

> Where was Seventh Avenue, the coffee shops, the crowded subways, the city which covered her aloneness because she had work to do there. Arizona was not for Regina Nestle, not this resort with its well-married ladies. While I scrambled over this new brown earth, my mother sat in the desert, a silent exile. (33)

Nestle perceives her mother's subject position and describes it here and throughout her text as that of an outsider and a rebel, as her own is.

The core of her book is a chapter entitled "Two Women: Regina Nestle,

1910–1987, and Her Daughter Joan." This essay bisects the auto/biography (the reader holds half the pages in her left hand and half in her right), and the typography is differentiated (the mother's voice is in italics). Joan speaks in some sections directly to her mother, in others to the reader. Her mother's writings, saved and published here by her daughter, are journal entries and letters to her employer, her doctor, and her daughter, Joan. Her primary legacy is this collection of her writings: "She [her mother] left me two satchels of scribbled writings . . . written on the back of long yellow ledger sheets, the artifacts of a bookkeeper" (78). Her mother's additional legacy is the "story of her desire" (87). Nestle's honest descriptions of this desire are free of sentimentality or a generalized celebration of female sexuality. Their "conversation" also reveals both Joan's and Regina's acceptance of difference in sexual identity. This lesbian-identified daughter defends and steadfastly affiliates with her mother, who is heterosexual. That which connects them is an admiration of sexual courage and honesty and an unromantic portrayal of the body as a site of political activism and rebellion. In her essay, Elizabeth Wilson states: "This is one of the few pieces of writing in which I feel the daughter sees her mother as another woman, as an equal, a sister and comrade, as an ally in the arduous struggle for sexual pleasure" (113).

Nestle knows about the gang rape her mother suffered at age thirteen, which resulted in a pregnancy and an abortion. She also watched as her mother was continually abused by men and exiled by her community. She expresses anger for her mother and hope that she will leave the brutality attending some of her sexual liaisons and join the daughter's "world of Lesbian friendships and passion" (121). However, there is finally a mutual acceptance of sexual identities and affiliation despite and across difference in Nestle's text. She narrates:

> My mother's legacy to me was the story of her desire. She has left sexual trails for me, private messages, how she saw her breasts, how her body swelled with want. . . . We faced each other as two women for whom sex was important, and after initial skirmishes, she accepted my world of adventure as I did hers. (87–88, 121)

Her mother's dying is described with medical and yet also sexual and intimate images. The doctor shows Joan her mother's body in the hospital: "[He] turns down your stained sheet to show me the heart burns from electric shock, but all I see is your pink nipple" (99). The nipple is both a sexual and a maternal image here. Her frank exposure of the full range of her responses to her mother's body continues her attempt at a unique auto/biographical project. Writing by both women continues even during the last day of the mother's life. The daughter writes, "Your eyes beg

me for help. You are tired and in pain. You write me a note: 'Death would be a treasure'" (99). This is addressed directly to her mother. She is the "you" of the text along with the reader.

On many levels there is conversation in this core chapter of Nestle's text. There are letters written to the mother by the daughter and sections of the text also written to the mother. She has included letters her mother wrote, in which she "speaks" directly to her daughter. There are also responses to and descriptions of these letters in later letters and other writings in the text.

Joan Nestle writes, "My mother always said she had to be a man in a man's world but she wasn't. She was a different kind of woman" (85). Her text is an autobiographical narrative that carries her mother's biography at its core and reveals the story of a different kind of woman to the reader, with all its intimate details. Nestle's confessional text is two narratives that connect the memories of two lives, with sexual images, both lesbian and heterosexual. She deconstructs and breaks downs the binarism that often exists in homosexual and heterosexual erotic discourse. The dialogue also has a political agenda that includes the right to sexual freedom for all women. Her own struggle is to openly celebrate her desire for a woman's body. The mother's story narrates pain and anger about her own rape, yet ends with "a sexual credo: she would not let this ugliness take away her right to sexual freedom, her enjoyment of the 'penis and the vagina,' as she puts it" (121).

Audre Lorde, *Zami: A New Spelling of My Name: A Biomythography*

Audre's Lorde's autobiography, like Joan Nestle's, is a personal history of her life of connections to women. She writes in her prologue:

> I have felt the age-old triangle of mother father and child, with the "I" at its eternal core, elongate and flatten out into the elegantly strong triad of grandmother mother daughter, with the "I" moving back and forth flowing in either or both directions as needed. (7)

Her mother's biographical narrative, geographically situated in her family birthplace of Carriacou, Grenada, is explicitly and concretely connected to Lorde's lesbianism. The love of women, for Lorde, as for Moraga and Nestle, is grounded in her love for her mother. In addition, she explains, the family's origin in Carriacou situates the narrative in a woman-identified space.[2] In this village, men spend much of their time on fishing boats, leaving women and girls to create a female-centered culture. Stories of her mother's childhood experience, in this culture, are unambiguously meshed with Lorde's lesbian identity. She writes: "*How Carria-*

cou women love each other is legend in Grenada. . . . There it is said that the desire to lie with other women is a drive from the mother's blood" (14, 256). Throughout her text, she directly and explicitly pairs her sexual identity and her love for her mother.

Claudine Raynaud theorizes that Lorde evokes more than her own family stories; she creates a matrilineal mythology as a "conscious political act." Her text is an "autobiographical manifesto" in many of the same ways as the texts of Rich, Moraga, and Nestle. Lorde, however, deliberately chooses African matrilineal mythology as the basis for her evocation of a lesbian utopia. As Raynaud states, "Her mother's land, Carriacou, becomes the occasion for the evocation of a lesbian paradise" (235).

In Lorde's text, she engages with her mother's voice, in the Bakhtinian sense I discussed earlier. That is, she models her text on her own constant inner dialogue with her mother's voice. Her words are spoken always with an awareness of her mother's words. As subjects of joined narratives they are, thus, joined in a "conversation" about intimacy and the erotics of the body. Lorde, however, also writes about a relationship with her mother that is fraught with tension and ambivalence. In her text, in fact, she uses elements of lesbian mythology to portray her yearning for reconciliation with her mother. Raynaud writes: "Yearning for reconciliation, Lorde unveils her most private desires. She makes explicit in its concrete implications the incestuous relationship of the mother and daughter, a recurrent motif in lesbian mythmaking" (228).

Prominent in this dialogue of two voices are images of bathing, grooming, and the warmth of a shared bed. She writes about the touch, smell, and warmth of her mother's body. In particular, her mother's bed and bath are described as sites of comfort, security, and grooming. In one such passage, she recalls a moment in her mother's bed when she was a young girl:

> I get up and go over and crawl into my mother's bed. Her smile. Her glycerine-flannel smell. The warmth. . . . Her large soft breasts beneath the buttoned flannel of her nightgown. Below, the rounded swell of her stomach, silent and inviting touch.
> I crawl against her. . . . Under the covers, the morning smells soft and sunny and full of promise. . . . Warm milky smells of morning surround us. (33–34)

The image evokes feelings of protection and closeness, but also sensual enjoyment of a woman's body. The child crawls into the mother's bed but also into her warmth, smell, and touch. The mother's body is round and inviting, though silent. The "large soft breasts" and the motherly "rounded" stomach that invites touch are maternal yet, also, erotic. The female body and its "milky smells of morning" draw the young Lorde into a sensual, wordless dialogue with her mother. The smell and moistness of milk associated with morning closeness draw the reader into infant sensations

as do the descriptions of breasts and rounded stomach. Touch is invited, and the daughter crawls against her mother as if to enter a delightful intimacy "full of promise" and to regain the sensual experience of the newborn and the lover.

Later in her text, she includes a description of her mother grooming her (Lorde's) hair. The passage depicts a particular moment in her childhood, shared with her mother, but also evokes wider connections to other Black mothers and daughters. She writes:

> Sitting between my mother's spread legs, her strong knees gripping my shoulders tightly like some well-attended drum, my head in her lap, while she brushed and combed and oiled and braided. I feel my mother's strong, rough hands all up in my unruly hair, while I'm squirming around on a low stool or on a folded towel on the floor, my rebellious shoulders hunched and jerking against the inexorable, sharp-toothed comb. After each springy portion is combed and braided, she pats it tenderly and proceeds to the next. . . .
>
> The radio, the scratching comb, the smell of petroleum jelly, the grip of her knees and my stinging scalp all fall into—*the rhythms of a litany, the rituals of Black women combing their daughter's hair.* (32–33)

The mother's strong legs are spread, and with them she grips her daughter tightly. This image is clearly tied to very early infancy and the birth experience. This is also another wordless memory of touch. Only the sounds of objects—the radio, the scratching comb—accompany the tactile sensations of stinging scalp and the smell of petroleum jelly. The daughter is "captured" unwillingly and subjected to unwanted combing and oiling, but she is also secured by this strength and by a feeling of belonging, within her mother's lap and within long-standing female rituals. This ritual is very particular, however, to Black, or African American, women. Only "unruly," "springy," tightly curled hair is groomed with sharp toothed combs and petroleum jelly.

Sometimes these dialogues, filled with images of bed and bath, join talk of intimacy and sensuality with expressions of anger and pain, in this mother-daughter relationship. The daughter's feelings of ambivalence toward her mother are vividly presented in Lorde's text, as in those of Rich, Moraga, and Nestle. For example, she writes: "I remember the warm mother smell caught between her legs and the intimacy of our physical touching nestled inside of the anxiety/pain like a nutmeg nestled inside its covering of mace" (33). Again, she has described the smell, feel, and warmth of the place between her mother's legs. She uses specifically erotic images that speak references to birth as well as to sexuality. However, Lorde also places this image "inside of the anxiety/pain." Both intimacy and anger are parts of her "reflected" existence as a daughter: *"I am a*

reflection of my mother's secret poetry as well as of her hidden angers" (32). There is the pain of ambivalence in her stories of her life that is tightly connected to her mother's, gripped by her mother's strong legs, held tightly against the smell and warmth of her "lap."

Conclusion

In her essay "Compulsory Heterosexuality and Lesbian Existence," Adrienne Rich states that all women occupy lesbian positions, as subjects, to some extent, because all women participate in "woman-identification," at some times in their lives. The experiences of daughterhood and motherhood are woman-identified, since only women *can* live them. Therefore, all mother/daughter texts are about woman-identification, in part. Lesbianism is also a woman-identified experience. Rich, in fact, links lesbian experience to motherhood in her essay. She states: "I perceive the lesbian experience as being, like motherhood, a profoundly *female* experience" (650–51).

As a group, or subgenre, the lesbian autobiographies of Rich, along with Cherríe Moraga, Joan Nestle, and Audre Lorde, are emphatically woman-identified. Rich theorizes, also, that heterosexuality is universally considered "natural." Therefore, any text that is identified as lesbian becomes a political statement. All of these texts of the 1980s have a feminist political agenda that drives a writing praxis that resists dominant literary conventions. I have compared and contrasted these texts in order to note and describe some commonalities within this writing praxis, especially in form and in the topic of the "conversation," between daughter and mother. The dialogue, in these texts, is about intimacy and bodies. Daily experiences are described using intimate images, such as grooming and bathing. The language is often sensual and associated with the female body. In each text, experimental and nonlinear structures combine many genres not usually joined and contained within autobiographical texts. Because of their embedded narratives and their dialogues of women's voices, which are about female-identified experiences, these auto/biographies are "profoundly *female*." The images in the texts are sited in the body, specifically a woman's body. In fact, two bodies are linked by touch, smell, warmth, and desire. The texts are also "self-consciously political autobiographical acts," or "manifestos," as Sidonie Smith states. Each text, as a political statement about women and writing, follows the feminist emancipatory agenda voiced by Hélène Cixous in "The Laugh of the Medusa":

> Woman must write her self: must write about women and bring women to writing, from which they have been driven away as violently as from their bodies—for the same reasons, by the same law,

with the same fatal goal. Woman must put herself into the text—as into the world and into history. . . . (245)

My Dancing Body

I just quoted Cixous from "The Laugh of the Medusa." She wrote that "[w]oman must put herself into the text." In an attempt to put my "self" into this text and to end this chapter, I feel compelled to introduce my self as a body. However, I am not comfortable with a public revelation of my intimate, sexual, or reproductive experiences. Instead, I have focused on some of my joyful experiences as a dancing body. In thinking about my dancing, I've asked myself these questions: Is my "self" an occupant of this dancing body? Would I be the same self if I couldn't dance, because of an injury or even a permanent disability? Is it brain chemistry alone that makes me feel a bit depressed when something prevents me from dancing or, rather, a deep fear that my dancing self is such a core part of my total identity that I don't know who I am without it?

Shuffle ball change, heel, toe, chassé right . . .

When I was five years old, my mother took me to my first dancing lesson: The class included tap and ballet sessions and was made up entirely of little girls, dressed in black leotards, transported there by our mothers. I don't remember the day of the first class or how I felt. I do know, today, it was the beginning of my almost lifelong experience of dancing. My mother and I shared parts of this activity. She drove me to my lessons and waited and watched during the class. For our yearly recitals, she made my costumes herself. I know, now, in a way I didn't comprehend then, that the lessons must have been a financial strain for my lower-middle-class parents. Yet, it was important, to my mother, apparently, that her oldest daughter acquire some grace and the cultural experience of dance. I can only wonder if she also was fulfilling her own childhood desire for dance lessons, which she never received.

A Dancing Fool

When I was five years old, my mother took me to my first dancing lesson: Since that lesson, over fifty years ago, I have not stopped dancing. I continued the tap and ballet for seven years. When I was twelve, I wanted to do more typical teenage kinds of activities, so I stopped going to my lessons. Also, by this age I had come to the painful conclusion that I did not have enough talent to be a professional ballerina. Instead, I enrolled in a ballroom dance class at my school. It was for both boys and girls and met on Saturday nights. I also began attending school dances and got to practice my new lessons.

In high school, I continued "social dancing" and added modern dance to my life. I was never very comfortable with this form of dance. I think I was so used to a structure and choreography—from doing tap and ballet at so young an age and for so long a time—that it was difficult to step outside the moves I knew and to begin creating with any freshness.

In college, I continued with modern dance and added synchronized swimming, which felt a lot like dancing. When I married and became a mother, right after college, international folk dancing absorbed some of my attention, and eventually English and American country dancing became my favorites. Since that time I have also done both English Cotswold Morris and sword dancing (long sword and rapper) and step aerobic exercise (a near dance experience).

Today, I am once again taking tap lessons. I am even thinking seriously about taking a ballet class. My class is all adults, mostly women. Our ages range from near thirty-five to over sixty. The teacher and studio owner is a fifty-five-year-old grandmother. I love the dancing and the music and the yearly recital with the satin and sequined costumes. In fact, I enjoy it more now than I ever did as a child.

Half gypsy, foot up, hey . . .

When I was five years old, my mother took me to my first dancing lesson: For twelve years, I have been a member of a Morris team. Morris dancing is a very old English traditional dance related to fertility, and each village in the English Cotswold region has its tradition. These traditions have been taken up by revival teams in the United States. Being on a Morris team means that I have committed to weekly practices, very strenuous and demanding, all year long and performances in various public festivals and Morris "ales," or invitational weekend gatherings of many teams, in the spring and summer. For the last seven years, I've been a member of the B. F. Harridans; it is a very serious and hard-working women's performance team. All of us are "fit"; our ages range from the mid-twenties to mid-fifties. Morris dancing is very aerobic yet very disciplined; my team has high performance standards. We dance to live music, and our musician travels with us. When the team travels, we often camp in the woods or on floors for several days. We eat, dress, shower, and nurse injuries together.

Why do I love to dance so much? What do I get from these hours and hours wearing Morris bells or tap shoes or aerobic garb and sneakers? Sabine Sielke, in *Fashioning the Female Subject,* writes: "[T]he body is a place of silence, rather than discourse" (222). It is certainly very difficult for me to find words to describe what I get from dancing and why I am so involved in these activities.

First, there is the physical sensation of moving quickly and jumping

high. I like to use and push my body's strengths and endurance as well as learn new physical skills and dances. The delicious sensation of walking around with sore calves the next day also feels great.

I love to move to music and as a part of a group of bodies, though I don't know why. Dance for me is a social act that is attractive because I have plenty of solitude at home. It is like sports in some ways, but there is also a creative element: I am part of a group that creates a dance performance. It is like singing in a group, but uses the whole body not just the vocal apparatus as a tool.

Also very important is the total break from the responsibilities of my job, where I occupy a position of authority and have to supervise the work of others as well as obtain the grant funding to pay their salaries. When I dance, someone else is the "boss" and has the responsibility. I just have to be "in charge" of my own body and remember the steps and the correct form and technique. (This is not easy, just very different.) Relationships with other dancers are also more through the body than through the intellect.

There is a third element that draws me to dance: the costumes associated with each form of dance. I enjoy the sensation of "changing hats" frequently. I love the chameleon-like experience I get when I move from professional garb, often a suit, to a leotard, tights, and tap shoes.

Being a girl dancer and now a woman dancer has connected me to other female dancers. There are very few men in my tap class and none in my other dance activities. The visual pleasure of watching other women's bodies that are trim, healthy, and graceful is lovely. They are all so different, yet similar, when sweating and breathing heavily. It is a joy I hope to experience for the rest of my life.

4

Conversations about Material Things, Longing, and Envy

> She wanted things. Politics and cultural criticism can only find trivial the content of her desires, and the world certainly took no notice of them. It is one of the purposes of this book to admit her desire for the things of the earth to political reality and psychological validity.
>
> —Carolyn Steedman, *Landscape for a Good Woman*

> I stared in at the spines of those books, wanting it all, wanting the furniture, the garden, the big open kitchen, with its dishes for everyday and others for special, the freezer in the utility room and the plushy seats on all the dining-room chairs. . . . I couldn't speak around the hunger in my throat.
>
> —Dorothy Allison, *Bastard out of Carolina*

Things of the Earth

Carolyn Steedman's autobiographical text, *Landscape for a Good Woman: A Story of Two Lives*, "is a book about *things* . . . and the way in which we talk and write about them . . ." (23). The author focuses on her mother's desire for material things and the concrete unavoidable fact of her envy for these things. She and her mother engage in a "conversation" about this class-based longing for material objects and, in particular, their gender-based longing for clothing. They talk about fashion: patent-leather Mary Janes, voluminously skirted dresses, upswept hair.

The site of desire, in Steedman's text, is envy, an envy born of the Great Depression. Material circumstances and, in particular, those of her 1950s English childhood of near poverty are central to her autobiographical and theoretical project. In fact, she writes about the economic realities of memory for the autobiographical subject, as few writers do. Also, stories of her mother's childhood are talked about in an ongoing conversation between mother and daughter. The material realities of this earlier time are always present alongside the post-Depression era details of the daughter's childhood. She writes about the lived relationship of the two histories and sets of stories and describes "the disruption of that fifties

childhood by the one my mother had lived out before me, and the stories she told about it" (5). The material circumstances of the general poverty of postwar England are almost irrelevant to the desires and dreams of Steedman's mother. She "came away wanting" from her working-class 1920s childhood. What she wanted was "fine clothes, glamour, money; to be what she wanted." And what she wanted was "to marry a prince" (6, 9).

Clothing, in particular, as an object of desire and as a means of class-related escape or "passing" is a constant narrative theme in *Landscape for a Good Woman*. Steedman's mother was a weaver's daughter who grew up in Burnley, a cotton-mill town, with a keen awareness of fabric and dress. Steedman's earliest memories are dated, in her text, with details of clothing she wore and an acute awareness of the fashions of the moment. The autobiographical narrative originates with and repeats an early dream memory of a woman who wore "the New Look" and includes the details of this look: "a coat of beige gaberdine which fell in two swaying, graceful pleats from her waist at the back (the swaying must have come from very high heels, but I didn't notice her shoes), a hat tipped forward from hair swept up at the back" (28). An always unfulfilled desire to be the woman with this "new look," an expensive look because it took great lengths of costly fabric, pervades the daughter's narrative dialogue in Steedman's text. Her mother's stories describe her awareness of the power of clothing and diet when used to gain economic status and class mobility for working-class women. The mother adopts a vegetarian diet for the same reason that she coveted the "new look":

> She thought she might save her life by eating watercress. . . . My mother did what the powerless, particularly powerless women, have done before, and do still: she worked on her body, the only bargaining power she ended up with, given the economic times and the culture in which she grew.[1] (141)

Dorothy Allison's autobiographical text, *Bastard out of Carolina*, can be read along with Steedman's text because it too unfolds through conversations focusing on hunger and longing for economic security, between a daughter and her mother.

I realize that I have taken some generic liberty in including this text that calls itself a novel. I do this using Lejeune's schema of autobiography, which can include what he calls "autobiography in the third person." *Bastard out of Carolina* is such a text. Lejeune emphasizes the contractual pact that is formed with the reader, based on the author's, narrator's, and protagonist's common name. Despite the fact that Allison's protagonist is named Bone, evidence of the autobiographical intent of this text is widely available, though external to the text.[2] Lejeune stresses, however, that the verifiability or unverifiability of such information is not

essential. Rather, he writes: "If autobiography is defined by something outside the text, it is not on this side, by an unverifiable resemblance to a real person, but on the other side, by the type of reading it engenders, the credence it exudes . . ." (30).

Lejeune further theorizes various subcategories of "autobiography in the third person." One category delineates texts in which the narrator uses the autobiographical "I" and gives it a fictitious name. The writer may use "one of those little names that we give ourselves in private; or a name that already makes you a character in a novel." Bone is such a fictitious name for Dorothy Allison. However, the contractual pact with the reader still persists in her text. As Lejeune states: "[W]e are on the frontier of fiction, but it is a matter of a 'fictitious fiction' if I might say, since it is simply mimed within a text that continues to pass itself off as autobiography." In all such texts, the use of this figure or fictitious name for the narrator "always involves the whole of the work and determines its entire composition."

Thus, by grounding my inclusive gesture in the contractual pact that the reader forms with Allison's text, I can compare her text to Steedman's. Her text is a "fictitious fiction" rather than what Lejeune calls genuine fiction: "We are not concerned with genuine fictions, that is to say, with autobiographical novels governed in their entirety by a fictional pact" (38, 46).

The fact of motherhood, as reproduction and material responsibility, gravely affected Allison's mother because of her class position in Southern rural 1950s poverty. Her mother's life was foreshortened by her daughter's birth. Allison, in the voice of Bone, her autobiographical narrator, muses:

> Who had Mama been, what had she wanted to be or do before I was born? Once I was born, her hopes had turned, and I had climbed up her life like a flower reaching for the sun. Fourteen and terrified, fifteen and a mother. . . . Her life had folded into mine. (309)

This perceived ending of one life with the birth of another, a daughter, is all about the need to provide, monetarily, for a child amidst a life of poverty.

An acute awareness of money, the economic worth of objects, and the insecurity and impermanence of working-class lives marks Allison's text. Greenville, South Carolina, in 1955 was "the most beautiful place in the world" through Bone's eyes at age five. However, as she grew older and began to be aware of the class markers and deprivations of her life, the beauty of it was harder and harder to perceive. Hunger and displacement made it difficult for her to believe her mother's abstract assurances. She relates: "'It'll be all right,' Mama kept telling Reese [her younger sister] and me, but she didn't explain how" (250). The "how" always had to do with money. Even her stepfather's abuse was also about money. Her

mother needed his wages added to her own to feed and house her children. Her wages from the diner where she worked as a waitress were not nearly enough. Thus, as Bone's narrative reveals, she had a very early awareness of the economic worth of material things. She recalls that at age eight she "knew to the penny what everything cost." She also knows that paying rent and buying food were constant problems for her parents.

Yet, inevitably, unavoidably, she covets things. The first things she yearns for are shoes. Her awareness of the goods of a middle-class life begins with this desire for shoes. At age eight, these shoes are no longer just something to protect and cover her feet. Earlier she and her sister wore no shoes for as long as possible during the summer, until "ringworm got so dangerous." Things shift, however:

> Though I had never complained before, suddenly I wanted new shoes, patent-leather Mary Janes—not the cheap blue canvas sneakers I was always getting at $1.98 every seven months or so. I wasn't a baby anymore. I was eight, then nine years old, growing up. . . . I knew there was no chance of getting a pair of those classy little-girl patent-leathers with the short pointy heels, but I looked at them longingly anyway. Mama just laughed. . . .
> "Who do you think we are, girl?" she said. "We an't the people who buy things for show."
> I couldn't help it. Just for a change, I wished we could have things like other people. (65–66)

They also weren't the people who had permanence and stability in their lives. Money and class determine perceptions of time and identity when they dictate that home is not a constant in a child's life. A craving for permanence often accompanies a working-class life. Bone expresses the losses to identity caused by the constant moves of a life of poverty. Her anger erupts finally and futilely one day as she uses a kitchen knife to slash and cut holes in the moving boxes and dish barrels that are the baggage of her family's impermanence. She cries to herself: "Moving gave me a sense of time passing and everything sliding, as if nothing could be held on to anyway. It made me feel ghostly, unreal and unimportant, like a box that goes missing and then turns up but you realize you never needed anything in it anyway" (65).

Class, Gender, and the Body

The subject position of both mother and daughter in Steedman's and Allison's gendered, working-class texts is linked economically to men through obligatory heterosexuality, through sexual vulnerability to abuse, rape, or domestic violence, and through pregnancy. The mother's body in the text is a site of power and life, through maternity, as well as loss of power. Paula Rabinowitz in *Labor and Desire* discusses the intersec-

tion of class and gender in working-class fiction of the Depression era in America. Rabinowitz foregrounds the reproductive and the sexually vulnerable female body in her discussion of these texts:

> Heterosexuality and maternity alter the body (and so the discourse) of the working class woman more profoundly than labor or hunger, producing a different story than that told by male proletarian writers. . . . Gender restrictions, poverty, and sexual vulnerability mark the points of development for the young working-class female subject. (99–100)

Rabinowitz's analysis of fictional texts is applicable to Allison's and Steedman's autobiographical texts. In both, the maternal narrative is profoundly altered by the biological experience of maternity. In Allison's text, her very young mother loses freedom and, quite literally, life as a free agent, through maternity (the daughter's birth) and its economic exigencies. Steedman's text, on the other hand, explores possible gains in female power through maternity. Her mother understands childbearing as a means to secure a husband (legitimacy). Attachment to a man promises a means of escape from poverty.

In Allison's text, Bone speaks as Allison's autobiographical subject. Her subject position and her mother's (Annie's) are constantly grounded in their female bodies. The stories and conversations include the ambivalence of the mother-daughter bond, but the material circumstances of isolated Southern rural poverty and incestuous abuse also shift and warp the bond. Violence and hunger, as well as the grinding daily effects of the mother's labor, as a waitress and prostitute, specifically locate this classed version of "the great unwritten story . . . the cathexis between mother and daughter" that Adrienne Rich discussed. In Allison's text, the experience of incestuous rape and abuse disrupts this bond with such violence that Annie and Bone must finally part.

Beginning the Story

In a 1992 interview with Amber Hollibaugh, for the *Women's Review of Books*, Dorothy Allison discussed her autobiographical connection to *Bastard out of Carolina*, as well as to a short story entitled "Mama," in her earlier collection, *Trash*. She stated that the texts grew out of a sense of responsibility "to tell the truth and to pay homage" to dispel the contemptible myths about "white trash." But in order to write about her family, she had to forgive them. Her most difficult task was to forgive her mother. Allison confesses:

> [I]n order to write Bone, the character I created, and to write her mother and to write those people, I had to forgive them, . . . I had to forgive my mother, really forgive her in order to show a child who

couldn't forgive her. And I don't think it would have happened the way it happened if she hadn't died while I was writing it. (16)

The writing of "Mama" was a "rehearsal" for the writing of *Bastard out of Carolina.* Prior to the completion of *Trash,* Allison wrote only shorter pieces because, as she said in her interview, the form "fit between your day job and your night-time meetings" (16). Class and economics had a concrete effect on the genre she chose to write. Many of the narrative details of "Mama" are the same as those in *Bastard out of Carolina.* Amber Hollibaugh writes that this was "a story she has obviously been writing inside her head since childhood—a chronicle . . . which she vowed she'd stay alive long enough to tell" (15). As Allison writes in "Mama," her mother's story is the central and daily element in her own life and story:

> My lovers laugh at me and say, "Every tenth word with you is *Mama.*
> Mama said. Mama used to say. . . ."
> I widen my mouth around my drawl and show my mama's lost teeth in my smile. . . . Sometimes, I hate my mama. Sometimes, I hate myself. I see myself in her, and her in me. I see us too clearly sometimes. . . .
> When Mama calls, I wait a little before speaking.
> "Mama," I say, "I knew you would call." (*Trash* 43–44)

Allison's texts reveal a compulsion to write this story, her mother's biography within her own autobiography, before writing any other text. She needed to complete this task before she could move on to others.[3] Taken as a single text, "Mama" and *Bastard out of Carolina* appear as a litany or a chant, with repetitions and refrains. She repeats both narrative elements and language. The preface to *Trash,* entitled "Deciding to Live," relates the beginning of the writing of the stories and, it may be surmised, the novel. She begins: "There was a day in my life when I decided to live" (7). She continues to relate that the writing saved her life. It was all that helped her survive a long period of wanting to die. The writing was a transfer of stories from her nightmares to the printed page. She writes in her later text, *Two or Three Things I Know for Sure:* "When I began there were just nightmares and need and stubborn determination. . . . And if I know anything, I know how to survive, how to remake the world in story" (4). Writing her autobiographical text also made Allison's experience of a working-class girlhood real: "I had been a child who believed in books, but I had never really found me or mine [her family] in print. My family was always made over into saintlike stock creatures" (*Trash* 9).[4] She further describes the madness of writing and remembering and, at the same time, her determination to get it down on the page and to have it be known. She describes a final night of fear and decision:

> But a night finally came when I woke up sweaty and angry and afraid I'd never go back to sleep again. All those stories were rising up in

my throat. . . . [T]he desire to live was desperate in my belly, and the stories I had hidden all those years were the blood and bone of it. To get it down, to tell it again, to make sense of something—by god just once—to be real in the world. . . . It was most of all my deep abiding desire to live fleshed and strengthened on the page. . . . Without it, I cannot imagine my own life. Without it, I have no way to know who I am. (11–12)

"To be real in the world," to have a voice, to self-authorize—Allison is "creating" herself with her text. Also, in *Two or Three Things I Know for Sure*, she makes it evident that she is creating an identity within a story she can bear to live with. She writes: *"Two or three things I know for sure, and one of them is what it means to have no loved version of your life but the one you make"* (3). Janet Zandy, in the introduction to *Calling Home*, theorizes that many working-class women's texts are the materials of survival as well as artistic expression for their writers. She finds in many a sense of "immediate and direct revelation" (12). Also, as I stated in my introduction, Phillipe Lejeune argues that the author is more than a person but, rather, *a person who writes and publishes*. The proper name of this author who writes and publishes appears on the title page of the text and links the text to a *real* person. In addition to creating an identity, the working-class writer creates a professional job and a salary for herself. The crafting of Allison's earlier text, because of the length of its form, fit the demands of her own working-class life: It could be written in the evenings when she returned from her wage-earning job. The story is a "warm-up" for a novel, like a blueprint for a house.

The only way to understand how Allison's writing was profoundly affected by the material circumstances of her life is to compare textual examples from "Mama" and from *Bastard out of Carolina*. The following are examples of similar or "parallel" passages:

> Aunt Alma was proud to be the first to tell me, and it showed in the excitement in her voice. "Your mama was unconscious for three days after you were born. She'd been fast asleep in the back of your Uncle Lucius's car when they hit that Pontiac right outside the airbase. Your mama went right through the windshield and bounced off the other car. When she woke up three days later, you were already out and named. . . . (*Trash* 33)

> Mama had fallen into her first deep sleep in eight months. . . . And what they did was plow headlong into a slow-moving car . . . and Mama, still asleep with her hands curled under her chin, flew right over their heads, through the windshield, and over the car they hit. . . . Of course, she didn't wake up for three days, not till after Granny and Aunt Ruth had signed all the papers and picked out my name. (*Bastard* 2)

The story is the same, but the second passage contains more details. The image is more complete. Not only is Mama still asleep, but one can see her with "hands curled under her chin." Not only did she fly out of the backseat of the car, but she, in fact, "flew right over their heads." The image is of people looking up at this sleeping, flying woman. The second passage, written by a more experienced Allison, who used her savings to live on and write full-time, is much richer in detail as well as humor.

A second dyad of examples follows:

> Mama would take me into the bedroom and wash my face with a cold rag, wipe my legs and, using the same lotion I had rubbed into her feet, try to soothe my pain. Only when she had stopped crying would my hearing come back, and I would lie still and listen to her voice saying my name—soft and tender, like her hand on my back. There were no stories in my head then, no hatred, only an enormous gratitude to be lying still with her hand on me and, for once, the door locked against him. (*Trash* 36)

She narrates a similar memory in *Bastard out of Carolina,* recalling her first beating:

> "Oh, my baby," she kept saying. I lay still against her, grateful to be safe in her arms. The air felt funny on my skin, and I had screamed so hard I had no voice left. I said nothing, let Mama talk, only half hearing what she was whispering. . . . I held on to her until she put me to bed, held on to her until I fell into a drugged, miserable sleep. (107)

Also, after the violent death of Bone's friend Shannon, her mother holds her and, in this passage, she sings to her. The song is one she associates with her earliest memories of a time when she and her mother were not separated by the violence of her stepfather's abuse and her awareness of the deprivations of poverty:

> I turned and pushed my face into Mama's dress. All my hardheaded anger was gone. As if she understood completely, Mama's hand stroked my neck and down my back while she crooned under her breath her own song—muted, toneless, the same hum I'd been hearing all my life. (203)

A Story of Two Lives

Both Allison and Steedman have reinvented the mother-daughter story with unexpected narrative elements. In *Bastard out of Carolina,* Annie does not choose her daughter over her daughter's rapist. She stays with this man (until her death, as we learn in "Mama" and in Allison's published interviews).[5] In her later text, she writes with some acceptance: "I just looked at her, feeling finally strong enough to know she had chosen

to believe what she needed more than what she knew" (43). Categories such as good mother or bad mother don't work in this text. This is a daughter's autobiography with her mother's biography at its core, which is, at least in part, about betrayal. The daughter feels betrayed by the mother she cares so deeply about.[6] Annie stays with her husband and loses her daughter, at least in a day-to-day way. In actuality, as revealed in her earlier text, mother and daughter go on. They just go on. Allison subverts the reader's expectations and questions fictional scripts of the mother-daughter story. In television, radio, and print interviews, she has, herself, stated that her auto/biographical text is about betrayal and, also, about her mother's sexual desire. It is about a stepfather who is a rapist and yet remains her mother's husband. Her narrative refuses to privilege or legitimate one experience over another.

Carolyn Steedman also resists expectations and reinvents the classed and gendered story of poor mothers and daughters. Her mother in *Landscape for a Good Woman* is not portrayed as a sexual victim of her heterosexually inclined body. Instead she (the mother) uses desire and reproduction to try to cross class boundaries, as she uses clothing and other markers to survive and to teach her daughters survival. She attempts to use reproduction and her body to gain economic status and security, through heterosexual connection with a man and his earnings. In *Landscape for a Good Woman* and in Steedman's earlier writing, she analyzes the way her mother tries to use her sexuality and its products to gain economic status and goods. The texts are, in part, about the failure of this transaction as an economic act of will. The absence of the legitimacy of the man/father as giver of goods and class status marks her stories of her childhood lived with a profound awareness of her own existence as an economic burden on her mother. There are many references, in the conversation between mother and daughter, to the material burdens of motherhood. Stephen Yeo, in his essay "Difference, Autobiography and History," summarizes this narrative element in Steedman's text:

> Her birth, she feels, was expensive for her mother, and it failed to purchase what she wanted, marriage to her father. Her mother would have preferred to cut a dash with clothes, and with a prince who came. Instead, her man went. . . . Steedman sees giving birth as a bargaining chip, used in deep desire, but for change which usually fails to occur. (40)

Economics/class affects the mother-daughter relationship in this text, as it does in Allison's. Steedman's narrative tells of the unwilling sacrifice of her mother's life choices and freedom for the creation of a child. Her mother voices anger and ambivalence and, also, confusion and guilt. In *The Tidy House* and *Past Tenses*, Steedman writes about receiving the kind of advice given little girls: "Never have children. . . . They ruin your

life."[7] This kind of cautionary tale results in a death of sensuality for a girl-child who knows that childbearing brings little pleasure or joy for a mother.

The daily reality of a working-class life, one in which "poverty hovered as a belief," affected Steedman's choice of genre, as it did Allison's (*Landscape* 39). She wrote most of her early, shorter, pieces while she worked as a primary school teacher. In one of these pieces, she states, in her introduction: "*Tidy House* was written in a school and I was the teacher of the children who wrote it" (2). Also in a parallel to Dorothy Allison, Steedman repeatedly wrote shorter mother-daughter narratives before she had the "economic" opportunity (enough income to live on) to write a longer, autobiographical text.

The Man/Father

In "The Laugh of the Medusa," Hélène Cixous writes: "[I]sn't it evident that the penis gets around in my texts, that I give it a place and appeal? Of course I do. I want all. I want all of me with all of him" (262). What is the place of the penis/man/father in these working-class daughter/mother texts? How is the mother's heterosexual desire for the man and his goods/status/body affected by class issues? What is the position of the father, as man, in these narratives of working-class daughters? The most interesting answers to these questions can be revealed by, again, comparing and contrasting Steedman's and Allison's texts.

In *Bastard out of Carolina* and "Mama," the man is the source of sexual violence in the daughter's story. He is her torturer and her rapist. Repeated beatings and sexual abuse mark her childhood. The final act of violence is a horrific rape, when Bone is twelve. Allison writes:

> "You little cunt. I should have done this a long time ago. You've always wanted it. Don't tell me you don't." His knee pushed my legs further apart, and his big hand leisurely smashed the side of my face. . . . My scream was gaspy and low around his hand on my throat. He fumbled with his fingers between my legs, opened me, and then reared back slightly. . . . He rocked in and ground down, flexing and thrusting his hips. I felt like he was tearing me apart. (284–85)

Her stepfather is also the source of alienation from her mother, because her mother cannot leave him. Bone, thus, must separate from her mother to escape her rapist. This separation from her mother is portrayed as the painful loss of a piece of her own life and life story. Bone relates:

> I had lost my mama. She was a stranger, and I was so old my insides had turned to dust and stone. . . . I wanted my life back, my mama, but I knew I would never have that. The child I had been was gone with the child she had been. We were new people, and we didn't know each other anymore. (306–7)

In Steedman's text, her father lives with his mistress and their two daughters part of the time. He also has a wife and "legitimate" children who gain status and goods from this legal marriage. It is the absence of this status and goods that dominates and shadows both mother's and daughter's lives. Even the daughter's sexuality is distorted by the physical and material economics that result from this lack of legitimacy. Her mother used maternity in an economic life and death gamble and failed: "I was her hostage to fortune, the factor that might persuade him to get a divorce and marry her. But the ploy failed" (*Landscape* 39). Her mother tried the same expensive game a second time when Steedman's sister was conceived. The young daughter was old enough to observe events that she later can understand as part of a desperate attempt at security by her mother. Steedman writes about the youthful observations and the later more mature understanding:

> My mother leant back against a workbench, her hands on its edge behind her. It tipped her body forward, just a little. She leant back; she laughed, she smiled. Ellis [Steedman's father] stood under the spot of light, a plane in his hand, a smile: a charmer charmed. Years later it becomes quite clear that this was the place where my mother set in motion my father's second seduction. She'd tried with having me, and it hadn't worked. Now, a second and final attempt. (53)

Despite her seductive attempts, she fails to cross class lines and to achieve the status of a middle-class wife. Instead, the goods of the transaction, her daughters, become profoundly weighty burdens. Her mother has few choices: She must feed her children. Steedman, however, has written of another choice, infanticide, in her essay "Kathleen Woodward's *Jipping Street*":

> On the evidence of *Jipping Street*, she knew as a child that she was a burden to her mother, that she need never have been born, that mothers indeed could kill their children. The child shrank from sexual knowledge, from an understanding of a process that had brought her into being, that gave women "so little pleasure, so little joy." (*Past Tenses* 124)

The father is both the cause and object of the distortion of sexual desire for the girl-child. He is also seen as the cause of her family's economic plight and position in poverty. She writes, in "Landscape for a Good Woman," the essay that was the rehearsal for her longer autobiographical text, of the daughter's youthful awareness of her father's role, through his refusal or inability to support them and to change their hopelessly poor economic life. In *Landscape for a Good Woman,* Steedman states: "By 1955 I was beginning to hate him—because *he* was to blame, for the lack

of money, for my mother's terrible dissatisfaction with the way things were working out" (29).

Steedman's father was a part of her life, however. He was there as a transient but continuous presence as she was growing up. She does write about her awareness that he too had virtually no economic power and was also victimized or subject to the middle-class patriarch and to economic expectations for men. He was a heating foreman when Steedman was a child, following an occupation that put his legitimate children in a class only slightly above a laborer's class. This was minimally "above" her mother's class position as a weaver's daughter.

In writing about a particular memory of her father, Steedman describes her perception of his own vulnerability and lack of any real power in the world outside their home. They had gone together on an outing to a bluebell wood; he began to pick flowers for her. The day was special and in fact she remembers her clothing: "I wore one of the two gingham dresses (I can't remember which colour, I can never remember the colour; they are both just the dress, the clothing of dreams)" (49). Very soon after they arrive, however, a forest keeper approaches them, shouts at her father for picking the flowers, and makes them leave the wood. Her thought at the time was "yes; he doesn't know how to pick bluebells." Yes, there is a straightforward judgment of his behavior that makes sense to a four-year-old. But her later memories are different. Her father "stood vulnerable in memory now," she writes. Her memory is of a generalized feeling of exposure and fragility in the economic, "classed" world that marginalized him, as it did her mother. She recalls:

> All the charity I possess lies in that moment . . . pity for something that at the age of four I knew and did not know about my father (know now and do not know), something about the roots and their whiteness, and the way in which they had pulled away, to wither exposed on the bank. (50–51)

Clothes and My Mother

As I read these texts, I reread my own 1950s childhood and my own mother's stories of her Depression-era childhood. My mother's desire for things and her focus on clothes, shoes, and makeup as "material stepping-stones of escape," in Steedman's words, shaped my life story and my subjectivity and still inform my actions in many ways (*Landscape* 15). I was born in 1942 in St. Louis, Missouri. The Second World War had a profound effect on my parents and, of course, on me also. I grew up in the 1950s in an inner-city apartment and, later, a very small house in that city's first large postwar housing development, which began the escape

to the suburbs for families, mostly white, two-parent, with enough income to purchase a mortgage on a seven-thousand-dollar home. The most influential historical event for me, however, was the Great Depression. I am still living some of my mother's economic and material stories from her childhood lived within the shadow of the Great Depression.

My grandfather was a tailor to the rich and aristocratically elite women in St. Louis. He brought his trade with him when he emigrated to the United States from Eastern Europe. My grandmother was born in St. Louis and did not work outside their home because she suffered frequent seizures caused by epilepsy. She gave birth to three daughters, one severely retarded. My mother, born in 1916, was her second child. They were poor, though not homeless, during the Depression. Their home was in a small apartment in a working-class neighborhood. My mother's stories of her childhood are not stories of abuse or alcoholism, but they are stories of grinding poverty and a lack of essential material things. Because my grandfather crafted clothing for wealthy people, my mother saw and touched fine fabrics and exquisitely made dresses, suits, and coats. She saw and heard the men and women who wore this clothing in her father's shop. She often went with him to their homes to make deliveries, at the servants' entrances, or to take measurements. Many of the women benevolently gave my grandfather their old, discarded clothing and shoes for his wife and daughters to wear. My mother wore this clothing and these ill-fitting shoes and knew she ought to feel grateful. Instead she felt anger and a profound envy. She had well-made, expensive, worn clothing. It was not made for her body or her fashion sense. Her feet hurt and grew misshapen because the shoes did not fit.

My grandfather died when I was five years old. I remember his tailor shop, filled with books of patterns and samples of wool and fur. I remember the luxurious softness and weight of the fabrics and the beautiful clothing he made. I have a few vague memories of the "special" women who came to the shop and the hushed silence I needed to keep in their presence.

My mother is a fine seamstress and a true expert at shopping and caring for fine clothing and shoes. She sewed all of our clothes and studied the bargain-priced merchandise in the department store where she clerked to obtain shoes and things she could not sew. These were always purchased on credit with payment booklets I remember vividly. My sister and I always had decent, clean, carefully ironed clothes. What we lacked—the cashmere sweaters, the pearls, the new and fashionable coats—we coveted. Envy and its close cousin, shame, were part of my subjectivity and my mother's.

Seeing myself as a classed subject and as the daughter of a classed subject is seeing myself earning and spending or, more frequently, saving money. Clothes are always part of this classed subjectivity for me. My

mother taught me with stories and with her envy about clothes and their meaning as escape and class markers. I live a "fiscally" lean and cautious life. I can't rid myself of the shadow of the Depression so that I can purchase *things* without feeling guilty—that is, except clothes. My mother taught me with her stories, as Steedman's mother taught her: "What we learned . . . was how the goods of that world of privilege might be appropriated, with the cut and fall of a skirt, a good winter coat, with leather shoes . . . but above all with clothes, the best boundary between you and a cold world" (*Landscape* 38).[8]

5

Conversations about Storytelling and Voice

When I was a child
my mother grew
out of my mouth.

 —Kim Chernin, "The World Song"

For everyone else the moment went by unmarked. I caught
it. For after that, my mother never, to my knowledge, told her
stories again in her own voice. From that moment in the book-
store she had taken over, or been taken over by, the voice I
had created for her.

 —Kim Chernin, *In My Mother's House*

The best I can do is to say Poppy recovered because she found
her voice. *To find a voice.* What does it mean? What does it
mean when a woman finds her voice? And when she finds it,
what then? . . . I mean she found a voice that narrates, orders,
considers, reconsiders, backtracks, and gives life a story, and
a story to her life. Maybe like a Zen paradox, the two are the
same and the struggle of life is to know what was always there.

 —Drusilla Modjeska, *Poppy*

This chapter is an exploration of two contemporary texts, *In My Mother's House* by Kim Chernin and *Poppy* by Drusilla Modjeska. Both auto/bio-graphical narratives center on the issues of voice, its fixing and unfixing in a written text, and storytelling. In both, a conversation between a mother and daughter, written and spoken, present, to the reader, an autobiography and an embedded biography.

Kim Chernin's autobiographical text, *In My Mother's House,* was published in 1983 and reissued, with a new foreword and a collection of family photographs, in 1994. The autobiography chronicles a process of text writing and storytelling that is much like the lived relationship between this mother and daughter. As the daughter listens and the mother speaks, a story of the mother's immigration and the daughter's desire for

assimilation, with all of the attendant confusion, guilt, and loss, is told. Both mother and daughter struggle to find voice and language to share and to properly record stories that are orally transmitted between them. This desire to record propels a "collaborative" writing between Chernin and her mother. In fact, it is the mother in this text who has persuaded her daughter to write her biography and to base it on transcribed interviews that the mother dictates for recording. Rose Chernin was an organizer for the Communist party in the United States and was imprisoned during the McCarthy era for her organizing activity. Kim Chernin begins the text with the biography of her well-known mother and ends it with her own autobiography. The narrative opens with the mother in the subject position of daughter and concludes with the daughter's story, with her in the subject position of mother. Rose and Kim Chernin's auto/biography expands to become "the tale of four generations, running from Rose's mother Perle, the only literate woman in the shetl, to Kim's daughter Larissa, who at the end of the book is entering Harvard" (Barker-Nunn 58). This dense chronicle of the women in the Chernin family focuses on the voices of the telling, listening, and writing relationships.

There is much theoretical discussion of the politics and the "scandal" of collaborative writing: personal narratives, life stories, *testimonia*, and "ghostwritten" texts. In some of the examples cited in such discussions, the model or subject of such texts is illiterate and of a marginalized group. Women's oral life stories especially have been transcribed from interviews and then published by the "author" or "translator" of such a narrative. My intent is not to confuse Chernin's "collaborative" autobiographical text with such narratives. Carole Boyce Davies looks at women's life stories in part for "what they contribute to autobiographical theory" but feels it is "profoundly important to define them as a separate literary genre. The critically defining feature is that they blur the boundaries between orality and writing." Davies believes that the recent feminist movement "which provides the space and the need to hear women's voices" is the impetus for the "collection activity and/or the giving of value to women's stories." She states that the "closest that mainstream autobiographical theory comes in allowing space for women's voices is in the 'collaborative autobiography'" (7). She sites a male-bonding text and relationship between Alex Haley and Malcolm X as an example of a collaborative autobiography. Such an example comes closest to the collaborative writing that Rose and Kim Chernin have undertaken.

Philippe Lejeune's theories are also useful in sorting out issues surrounding the notion of "collaborative" autobiography. In his essay, "The Autobiography of Those Who Do Not Write," he theorizes that the effect of the autobiographical contract blurs the distinctions between or facilitates a confusion between the author, the narrator, and the "model"

in a text such as Chernin's. "This fusion" he writes "takes place in the autobiographical signature, at the level of the name on the title page of the book." He feels that the "division of labor" in such a work only calls attention to the multiplicity of "authorities" implied in all writing. He states:

> By relatively isolating the roles, the collaborative autobiography calls into question again the belief in a unity that underlies, in the autobiographical genre, the notion of author and that of person. We can divide the work in this way only because it is in fact always divided in this way, even when the people who are writing fail to recognize this because they assume the different roles themselves. Anyone who decides to write his life story acts as if he were his own ghostwriter. (187–88)

Lejeune also compares the role of the ghostwriter or transcriber, the role that Kim Chernin sites herself in, to the position of "translator." He makes an important distinction between the writer and the translator, however. The writer creates a text where one did not exist, unlike the translator. As he writes:

> The position of the writer is in many respects similar to that of the translator, with just one difference, but an enormous one: in the writer's case *the original text does not exist*. The writer does not transmit the text from one language to another, but draws the text from a "before-text." (264)

How can we say a text has voice? It makes no sounds. We read it, see it with our eyes. But this is not the same as actually hearing a voice. Women's voices can transmit stories even when women are denied access to literacy and to centrist publishing. The stories of family members—mothers, grandmothers, aunts, and even daughters—in Chernin's text, are talked, spoken among women, before they are written. The text, of course, is the written word. But incessantly, the issues of voice and storytelling, not storywriting, are the topics of the conversation in this autobiography. Jeanne Barker-Nunn, in a comparative article about *In My Mother's House* and Maxine Hong Kingston's *The Woman Warrior,* theorizes about some differences in women's and men's storytelling:

> If male history and myth originated in tales told around the campfire, Kingston's use of "talk story" as a verb and Chernin's refrain of "mama, tell me a story" would suggest that perhaps female history finds its archetype in the nursery tale or story told around the hearth. (56)

I agree with Barker-Nunn's assertion that the storytelling relationship between mother and daughter, in these and other texts, suggests stories of childhood told and listened to at bedtime or while domestic work is

being done. This description of storytelling is useful in approaching an analysis of Chernin's text.

Alternate meanings of the word "voice" include call, cry, music, sound. The *écriture feminine* (Cixous) or imaginary/semiotic language of Kristeva's theory is a language of the pre-symbolic, of the developing child's time of connection to the mother, of voice that is closest to calls, cries, and musical sounds. It is an early language based in the infantile pattern of playing with sound. It is also language based in a "women's time," as Kristeva writes:

> As for time, female subjectivity would seem to provide a specific measure that essentially retains *repetition* and *eternity* from among the multiple modalities of time known through the history of civilizations. On the one hand, there are cycles, gestation, the eternal recurrence of a biological rhythm which conforms to that of nature. . . . On the other hand, and perhaps as a consequence, there is the massive presence of a monumental temporality . . . which has so little to do with linear time (which passes). (191)

Kristeva's theory of repetition and eternity connects with Chernin's refrain of "mama, tell me a story." The bedtime story or the story around the hearth repeats and repeats, often with no relation or recognition of more "public" or historically timed or measured events. Kristeva sees that mothers continue to tell their children stories and will continue indefinitely in a pattern that resembles eternity. She also writes about female biological cycles of menstruation and gestational times. Mothers give birth to daughters who become mothers who give birth to daughters, resembling the four generations of women in Chernin's family. The repetition of the storytelling act structures this text as well as the generational ages and roles of women. A daughter ages and exchanges her role as a child for that of a mother and then a grandmother.

Thus Chernin's text is about the "talking" of a text and also her perception of "women's time" in her own auto/biography. Time, within this text, moves in many different patterns. Some are circular, some linear in the broadest sense. The time of the present, as she writes it, and that of many different past events often mixes. The narrative is most often governed by a time that is linked to an occasion of storytelling.

The connection between voice and time is explored in Chernin's text. Her mother's voice is listened to throughout the daughter's lifetime through the stories she tells. The repetitive ongoing nature of the stories also describes the voice that tells them. She recalls: "Her voice moved out along its well-worn track" (*In My Mother's* 259). There is in her text a sense that voice has a temporal quality and that time can be measured as the voice that tells a family story changes, as one teller passes the

storytelling role to the next. She writes that her mother "foresaw and planned . . . [the] moment when the voice in these family chronicles would pass over to me" (209). At the end of the text she passes the role of storyteller to her daughter, and again the voice changes with time: "Those years, after her birth, belong to my daughter and must be told, if ever, in her voice. That, after all, is the pattern my mother has established" (294).

Chernin begins the foreword with a musing on the two kinds of stories her mother told, one kind taken from its keeping place in her mother's lap and the other from "a place high up on the wall":

> There were two kinds of stories my mother told when I was a small child. One kind was kept in her lap. . . . The other kind came from a place high up on the wall. From this kind of story she would frequently look over at me, our eyes would meet, we would have the same sudden, momentary suspension of breath. I would get the impression the story came from inside her, from back behind her eyes, which were still looking at me but not seeing. I would shift to the edge of the bed, get up on my elbow, and look over the rim of her eyes, and sometimes, for an instant, I was able to look into the place the story came from. (vii)

Chernin begins her text and conversation within, with this description of two kinds of stories that come from different "places." Both kinds of stories pass from a mother to a daughter who "came into the world as my mother's listener" (xi). There is no mention of time in this description of storytelling. It apparently is ongoing. In fact, it is described as a process that is still continuing as she writes the text: The mother and daughter are still living and are continuing to share stories. It is also a very provocative description of some of the stories coming from places, such as the maternal lap, the place of sexuality, birth, and holding of small children. These are also the stories that have a "beginning and an end," and even if the telling is interrupted and then continued the next night, "you could find the place you had given it up, the same word, in exactly the same place you had left it." This is the story of repetition and eternity that never changes and is comforting for just this reason. If the mother slips and makes even the slightest change in the narrative, the child forces the return to sameness and the pattern of repetition. She recalls that these disruptions would cause her to "snap to attention." She writes:

> Loyal above all to the permanence of the tale, her violation of its implicit promise always and forever to remain as it had been before filled me with outrage. I would order her back into the narrative sequence with a stern frown and scarcely concealed sense of betrayal. (vii–viii)

The very young daughter is comforted by the ritual of sameness and the pattern of storytelling.

The other "place" where her mother's stories "came from" is more abstract and yet also embodied and engendered for the young Chernin. Since it comes from a place high on the wall that a child cannot really see, she searches for the place of origin within her mother's eyes or beyond. It seems to come from "inside her, from back behind her eyes." Chernin more fully describes this type of story as a nonlinear, nonfixed narrative always continuing to be revised as it continues to be retold, as oral stories often are. Publication finally fixes the stories. She continues:

> But the other kind of story, that kind from which eventually *In My Mother's House* was made! That kind of story, coming from the heavy darkness behind her eyes or the place high up on the wall, started wherever it wished. The middle of one story was sometimes the beginning of another or even its end. This kind of story never took you exactly in the same way to the same place twice and really, once you came to give the matter some thought, you couldn't speak of beginnings or endings, it was all a twisting and unraveling and turning back on itself with unexpected moments right in the middle of the most familiar scenes. (viii)

The stories, which comprise the conversation within the auto/biography, are "twisting and unraveling" rather than linear and are retold throughout the entire length of this mother-daughter dialogue. They also are stories that have a voice, a collective sound or music, that is a combination of the daughter's and mother's voices. The mother tells the first story, but the presence of the daughter as listener, scribe, or co-teller is necessary for the creation of the voice. Chernin describes the process in her foreword: "When my mother and I were not there, together, her stories lost their voice" (ix). This struggle to find the right "voice" for her mother, in her text, is central to Chernin's project. She writes:

> To get my mother to sound like my mother on a page, I had to find a voice that was as richly textured as her presence, a voice that could, being a paper voice, rely entirely on itself, having been forced to dispense with lemon, teacups, apples, living breath. It had to sound like my mother, but not the way my mother literally sounded; it had to have something of her in it but something of me as well, of the way I had listened to her voice as, throughout our life together, it had told her story to me. . . . The voice that would eventually emerge to tell my mother's story for *In My Mother's House* had to draw on the mother's voice as the daughter, the listener, had caught it years ago, as if it fell forward into the rapt, listening girl, before she or the mother had any idea the daughter would become a writer. (x)

The creation of the voice and the creation of the text take the efforts of both mother and daughter. In a "collaborative" auto/biography like Chernin's, the memory and writing are separated. The mother provides the

memory; the daughter is the scribe or writer. But the whole process is set within a dialogue or conversation about the writing of the text and the remembering that is in the text also. And, as Lejeune theorizes, this dialogue about the making of the text "is likely to leave oral and written traces" (188). In addition, despite her attempts to recreate sounds in some new way, the voices and stories are fixed by publication. The change in the spoken voice of the mother, after she has read the first edition, amazes the author when she "hears" this changed voice at a book party to celebrate the publication of this edition of the text. She overhears her mother relating a story that Kim had recorded in her book; it was a tale that Rose had told her daughter many times. Chernin writes:

> ... but this time in a word-for-word repetition of the version I myself had worked out for my book. My mother was telling her life story in my words. . . . [M]y mother gave up her sovereign right to transpose her life's story and for the first time surrendered to it as a written tale.
>
> For everyone else the moment went by unmarked. I caught it. For after that, my mother never, to my knowledge, told her stories again in her own voice. From that moment in the bookstore she had taken over, or been taken over by, the voice I had created for her. (xii–xiii)

Chernin explores the process of finding the textual voice and the effect of the written voice on the spoken voice, as well as the writing of the change. She poses questions as she creates her text: Who is writing the text, and, more importantly, what constitutes the text? Written and spoken voice, explored here in detail by Chernin, and the subsequent change in lived existence that is, then, also written about are not separate entities. The autobiography, as a textual object, has "permeable" boundaries and, itself, is described in the second edition. Issues of creation and recreation are also talked about. As a young child, Chernin writes in "The World Song," she felt she created her mother as a subject by speaking her into existence: "When I was a child / my mother grew / out of my mouth (*Hunger Song* 12).

What is most unique about this text is that it is an exquisitely self/ selves-conscious exploration of the tale/telling being written. The physicality of voice, coming from the teller's mouth, has a sound and is heard by the listener's ear. Chernin writes that her mother's voice has a new sound and cadence and even different words after her word and story are converted to a written voice that is then "read" at oral presentations. Rose Chernin's voice is not fixed and is not owned only by her. Subject and object, with their voices, merge and change continually in this mother-daughter story.

Chernin's text is also about collaboration in the storytelling and writing processes. The mother gives her life stories to the daughter who writes

them. Appointments to work together were formally scheduled. Chernin recorded the interviews on audiotape and then transcribed them and included them as written text. Spoken voice thus becomes written page. The interviews cover many years of visits and separations in their relationship.

Most of the women's autobiographies I have discussed hint at or suggest what only Chernin's text explicitly narrates and describes. She and her mother are very close in their living and in their storytelling. Chernin writes about her ambivalence about this tightness and merging of texts of mother and daughter. She expresses a fear of losing her separateness as she begins the process of working with her mother on their common text. She writes:

> This enterprise will take years. It will draw me back. . . . It will bring
> the two of us together to face all the secrets and silences we have kept.
> The very idea of it changes me. I'm afraid. I fear, as any daughter
> would, losing myself back into the mother. (*In My Mother's* 12)

Her text also contains telling silences about those experiences that are "too private" for an immigrant Jewish family to share with an alien, and often anti-Semitic, American culture. In fact, she worries in her text that she has unintentionally revealed carefully hidden family secrets. Chernin also writes of her mother's experiences and, later, her own with the immigrant/assimilation compulsion to Americanize speech. Her mother says: "My family keeps its secrets. And I as a small girl learned how to listen in silence. . . . Now, I am trying to keep my tongue from uttering these things. But my tongue has its own intentions" (110, 113).

The "accented" voice of the immigrant carries identification with a marginal group to the American mainstream listener. It carries markers of another place and culture and, for women, other roles. Why is this so negative in America? One can be assimilated to the eye much faster than to the ear. I remember my shame when my grandmother's accented speech marked my difference from my friends. She sounded/was old-fashioned, not modern, not American. But accent is not negative in music or color. Yet, maybe, it is the same thing. Something accented stands out. It is louder, brighter, more visible. An accented voice makes it impossible to lose oneself in the faded, muted colors and sounds of nonimmigrant America.

What I find interesting, also, are the personal silences in Chernin's autobiographical text, as compared to the material in her other published work. For example, there is no mention of her publicly declared lesbianism or her experiences with anorexia nervosa, which she narrated in two book-length texts, *The Hungry Self* and *The Obsession*. There is one brief note of this. As her mother greets her at the airport, after one lengthy separation, she exclaims: "You're so thin" (119).

The formal storytelling/writing process, undertaken to produce the

material in Chernin's text, lasted for seven years. There were times between visits when the interviewing and telling was suspended. As they neared the end of these appointments meant to record the mother's story, Chernin describes a wished for, though feared, merging of stories and feelings. She writes:

> Now, for the first time in my life I take my mother in my arms to comfort her. I kneel down on the floor in front of the couch where she is sitting. I throw my arms around her and take her head against my breast. She is not crying, but I feel crying in her, a deep shudder. It rises across the entire length of her body and enters me. Now I am weeping the tears she refuses. We are rocking together, and I realize in the rush of terror I feel that this is the closeness I have longed for all my life, the silent falling of barriers. (182)

The Family Album

Before ending my discussion of *In My Mother's House,* I return to the place where Chernin starts the second edition of her text. She begins not with narrative but with photographs in the section she calls "The Family Album." It is a series of posed yet mostly "amateur" photos taken from her family's collection. She describes the care and labor associated with the keeping of this collection and also the fact that the album mostly stayed in a drawer. Chernin recalls:

> Our photograph album was kept in the bottom drawer of the linen cabinet, under the embroidered Russian tablecloth. It was a large red album, with heavy black pages, the photos inserted, with considerable work. . . . I was the only member of the family who fetched it out, cumbersome, forbidding, irresistible as memory itself. (xxvii)

As her description states, this album was a cherished belonging stored with other cherished yet foreign and forbiddingly formal objects like the "embroidered Russian tablecloth." The album was never out in the open as a daily part of their lives but rather was under the tablecloth. The viewing of the album was for special occasions only, as was the embroidered cloth. Chernin was the only one "who fetched it out." She was the one who held it and gazed at its contents finding the images "forbidding, irresistible as memory itself." Her position as observer continues as she becomes the chronicler of her family through the later photographs she includes in this section of the auto/biography and through the written text.

"The Family Album" is a fully captioned or annotated collection of photographs; it begins with a formal photographer's studio image of Rose Chernin and her mother, Perle, taken in 1916.[1] The last of the photos is a "snapshot" of Chernin and her mother taken at Sunset Hall, a retirement home in Los Angeles, where the mother was then living. She does

not note who the photographer was. Her mother's image is sunlit; her eyes are closed. Chernin, in shadow, touches her mother's face and smiles lovingly. The remainder of the photographs chronicle the four generations of her family and are taken in Russia, Vienna, and California.

Sidonie Smith, in her 1994 article, looks closely at four Australian women writers' texts and their engagement with family photographs as "an occasion to re-cite, re-site, and re-sight autobiographical subjects and practices" ("Re-citing" 512).[2] She explores the process of piecing together family histories from photographs, as Chernin does. Chernin's "Family Album" section introduces and supplements her written text. Yet, she also writes "around" and in response to the photographs, re-siting and re-citing an alternate history and her place in it. She locates the "'I'" in a different narrative, a different history, a different filiality, a different look" (Smith, "Re-citing" 513). The different "look" in Chernin's text informs the reader with visual images that are placed next to her written images. This other narrative further problematizes the "fixity" of the auto/biography of Kim and Rose Chernin.

Drusilla Modjeska, *Poppy*

I conclude this chapter and this analysis of daughters' texts with a biography/autobiography/novel by Drusilla Modjeska. Modjeska was born in 1946 and grew up in England. She emigrated to Australia in 1971 after living in New Guinea. Modjeska's *Poppy* was published in 1990 by an Australian press. It is available only in Australia; the American literary-critical community has taken very little notice of this text, or her other work. In her acknowledgements, however, she notes the influence of writers whose work ties her to contemporary feminist scholarship in Europe and the United States. She connects her work to the writing of Carolyn Steedman, Elizabeth Wilson, Denise Riley, Jessica Benjamin, and Luce Irigaray. She especially notes the influence of the writing of Christa Wolf, "without whose example of the possibilities of form and voice, I couldn't have begun this task" (318).

Modjeska's text comments on and narrates a complex relation to location and place. She left England, her "mother country," partly to place distance between herself and her mother. She refers to this journey toward independence with her epigraph by Colette: "To renounce the vanity of living under someone's gaze." However, her text is set almost entirely in England. It carries her mother's name and follows the chronology of her mother's life in England. She is writing from her home in Sidney and during several visits to her mother in England. Her attempt to be "not English" and her confusion about the location of her "home" is evident in the text. She questions whether she can travel from England and from her mother, whether it is possible to achieve separation. She asks:

Is this where I lived, where I grew up? It's still England. . . . It's easy enough to say that I'm the visitor, it's me who's changed. But it doesn't answer the question. What I want to know is whether it's the same sky, that sky you see on a clear day? Does it stay in the same place when the earth moves or does it move with the earth, taking us with it? (242)

Modjeska's text contains a "dialogue" between the texts of daughter and mother that is about storytelling and voice, as in the conversation in Chernin's text. Her text is also about her attempt at re-citing, re-siting, and re-sighting her mother's story through the use of family photographs.[3] The book was begun four years after her mother's (Poppy's) death and includes recorded memories of long conversations during the last year and, particularly, the last summer of Poppy's life. Modjeska declares her project a biography and describes her work as "research." She also writes about the process of gathering "evidence" through these conversations and through her mother's papers, diaries, and letters, which she inherited after her death.

As Smith notes, Modjeska also uses the "evidence" of family photographs in a frustrated effort to know her mother, realizing that without this knowledge, without "evidence that would restore her to me" (12), she "could not know [her]self" (5). She uses the walls of her study as "architectural" research space. On one wall she draws the lineage of a family tree to map out "straight forward and unambiguous" facts about the very bloodlines and relationships that are the historical text of a family: who married whom, who gave birth to whom, when were the births, the marriages, the deaths? (9). On another wall she mounts many "snapshots" of her extended family as more visual "evidence." But, as she discovers, "there's nothing to join them together." She can't tether them with "straight lines drawn in ink," as she has done with the names and relationships in the family tree. She laments, "[T]here's nothing to join them together. . . . The photos themselves explain nothing" (9–10). Smith writes:

If Modjeska begins her "life-writing" project desiring to know her mother by piecing together through bits of evidence the "real" story, she discovers that she cannot get to any "real" story through family documents; she can only get to her version of an unrecoverable story. ("Re-citing" 515)

Voice

The mother's "voice" in Modjeska's text is taken directly from her own writings—diaries and letters—included in the auto/biography. Specific entries are dated and chronologically presented. The voice in these entries often overlaps the daughter's voice as the text explores and describes

the intersubjectivity of mother and daughter. A central point in approaching this text is, however, the "reliability" of the diaries, letters, and other papers. Modjeska's text has a dedication and an acknowledgment section that both proclaim the fictionality of the hard "evidence" that she compiled and relates in the guise of historian. On the first page she writes: "For my mother who died in 1984 and never kept a diary." In the final pages she describes her own project more directly:

> When I began this book my intention was to write a biography of my mother and I expected that I would keep to the evidence. In the writing of it, however, I found myself drawn irresistibly into dream, imagination and fiction. The resulting *Poppy* is a mixture of fact and fiction, biography and novel. . . . The evidence I have used, the diaries and letters, the conversations and stories, come from memory, the papers I have been given, and from the imagination I have inherited. Nothing should be taken simply as literal. (317)

Imagination and memory are discussed in the dialogue that is the text and the dialogues that it is based on, that is, those she recorded after their final conversations. Expectations of reliability and of genre boundaries are problematized in this text. For me, the experience of reading this work was a surprising one. The author drew me into the fiction that her narrative was a historical compilation. I forgot the dedicatory statement as I read this biography of a mother's life that was also an autobiography of the writer. As I analyze issues of memory and imagination in this text I want to question why Modjeska does what she does. I have focused on the silences and major gaps in the dialogue between mother and daughter for answers to this question. Smith theorizes that Poppy's silences are a "gift of imaginative license, an imaginative license that sanctions another way of knowing" and that this gift releases the daughter from "the necessity of securing her mother's version of her own story" and allows the daughter to "fashion her own narrative" (Smith, "Re-citing" 517). This analysis of the mother's silences, moreover, supposes that their stories are inseparable and that what is presented as biography is also autobiography. The text is neither and both.

In fact, issues of voicelessness and silence are central in Modjeska's text. A discussion of the political powerlessness of women and, in particular, of this woman, and her madness and loss of voice, is also central to the topic of conversation between mother and daughter. Poppy's silence and depressive illness must be discussed first, however, because it had a profound effect on her daughter's life and on her writing practices in this auto/biographical text. I believe Modjeska created a voice to *talk* to, to have a conversation with, because her mother "lost her voice" completely for many years and, also, her daughter lost this mother's voice and physical presence, in her own life. When Poppy did return to a speaking relation-

ship with her daughter, she continued to undercut the clarity and verac-
ity of what she said to her daughter because she lacked a belief in her
right to speak. Poppy never felt adequately authorized in her speaking
or writing.

Modjeska's biographical narrative of her mother begins with Poppy's
birth, in 1924, in England. Her father was not present because he was in
London celebrating the election of a Labour party government. Poppy's
mother wept when this daughter was born, following the stillborn birth
of her twin brother. She was cared for by a Nanny, as well as her mother,
China. The sketchy details of her childhood include references to both
imposed silences and angry outbursts. Her childhood was divided between
two mothers, China, conventionally feminine, and Nanny, who encour-
aged her and provided reassurance and comfort. Modjeska writes about
this early split, and the gap it created in her mother's life, as one that
affected both her voice and her expectations for her future as a woman.
She asks: "Was it in that gap that she learned to be silent, but not bowed,
watching, gathering information and waiting her turn, waiting for the
future Nanny promised and China forbade?" (32). She does not clarify
what the forbidden future was, but it included possibilities that were
nontraditional for women at that time. At sixteen, she took advantage
of a new freedom for women, created by a war in Europe, and enlisted
in a military unit. This escape allowed her to work and meet people she
could never have met at home. However, later, it was also the exigencies
of the postwar period that propelled her into a conventional marriage
with Richard. As a young wife and mother, Poppy eventually found her-
self very isolated and frustrated, living in a small community, far from
friends and family, with a life centered on the domestic routine of a
middle-class housewife. Poppy's depression first showed itself as a silence.
She had much to say, but her role as wife and mother precluded such
statements. She desired work and responsibility outside of the home. Her
angry voicelessness is described as a destructive threat to her marriage
and her family. Modjeska writes: "Her silence, practised to an art in
childhood, infected the marriage. It was not that she was veiled. On the
contrary she was wide open, with nothing hidden, but the messages that
came from her were, literally, unspeakable" (49). Her husband Richard
was unable to understand her strange desires, so she spoke of them less
and less. Her daughter heard her voice less often, also, as she was grow-
ing up and felt this loss as a profound deprivation. Poppy's eventual si-
lence and slide into clinical depression is recalled, through Modjeska's femi-
nist agenda, as a natural and understandable response to the life of an
isolated married woman with children. She writes that her voice finally

> stopped one night and disappeared into air hung with words that
> no longer belonged to any of us. . . . Her silence was a symptom and

a cause. . . . The voice she needed hadn't been invented, or if it had,
it hadn't been heard in the south of England. (4, 83–84)

Poppy's breakdown and hospitalization is described through her daughter's memory as well as her imagination. Also Modjeska uses historical documents and her own research in the treatment of women in such a medical facility in that time period. Frequent electric shock treatments were administered. Her family was discouraged from visiting her. This daughter's portrayal of the tragedy of her mother's mistreatment is not just the story of one woman, however. She places her mother in a cultural setting that many women experienced. She states: "In that environment it was impossible for anyone to admit that Poppy's despair and confusion, far less her terrors, were reasonable, without dismantling the edifice of the family by which we all lived" (85). Poppy was angry at the limitations she experienced as a woman and frustrated by her loss of freedom and vocation. She wanted to work as a professional and to be educated, like her husband.

Modjeska also recalls the effect on her own childhood, when her mother was placed in a sanatorium. Her description of loss recalls the texts, discussed earlier, of Virginia Woolf and Sara Suleri. This mother also was lost to her young daughter because she was profoundly "inaccessible." The loss is described as so great that the writer's own words and narrative are threatened:

> The central recurring fact . . . is the door that closed on us all when
> Poppy went into the sanatorium in 1959. . . . [I]t happened without
> warning, a bolt out of a clear sky. She was there, and the same; then
> she was not. That she went is a fact so certain that not only memory
> but narrative becomes problematic. (40)

It was specifically this great loss of her mother through a mental breakdown, but even earlier through her silence (because there was no cultural space within middle-class English marriage, for her voice to be heard) that left Drusilla Modjeska with no one to talk to. In her narrative text, thus, she creates her mother's voice, using her imagination. She also creates a mother who wrote diaries and letters and who, thus, engages in a conversation, with her daughter's written voice.

Poppy recovers her voice finally and is thus released from the sanatorium. This voice allows her, once again, to give her life a narrative framework and to have some control over her own story, rather than be controlled by it. This recovery process is recalled by her daughter:

> The best I can do is to say Poppy recovered because she found
> her voice.
> *To find a voice.* What does it mean? What does it mean when a
> woman finds her voice? And when she finds it, what then? . . . I mean

> she found a voice that narrates, orders, considers, reconsiders, back-
> tracks, and gives life a story, and a story to her life. Maybe like a
> Zen paradox, the two are the same. (93–94)

Her mental state was still too fragile, however, to return to her family.
She lived for several years in a community known as Pilsdon, which was
a farming community, based loosely on Socialist principles. At Pilsdon,
she was given a notebook to start her diary writing: "*I am not good enough,*
were the first words she wrote" (97).

Poppy does continue to write and Modjeska's text continues to cre-
ate a space for years' and years' worth of diary entries that she inherited
after her mother's death, in piles, tied with string. Poppy's story in her
diary continues far after the grim time of her childhood, her nervous break-
down, and divorce. The story of her institutionalization, shock treatments,
suicide threats, and silence is not the end of the text. The daughter's nar-
rative continues past the time of the broken and victimized mother to an
imaginative writing of her mother's life as a woman. The narrative through-
out is based on that mix of memory and imagination, not to be taken
literally, that is the biography of Poppy. As she imagines how her mother
might have put together a new life after she regained her voice, she "cre-
ates" stories of experiences outside the narrow limits of marriage and the
traditional family. As Smith notes: "[T]he daughter re-sites her mother,
releasing her from a singular snapshot [her wedding portrait]. And she
resists the temptation to fix her own familial look, to site her mother in
a static identity" ("Re-citing" 518).

Modjeska also theorizes that her text may reveal her own fears and
feelings of unworthiness. She writes: "Maybe all I have succeeded in map-
ping is not Poppy but my own neuroses" (233). By creating this hybrid
of fact and fiction in her imaginative impersonation of her mother, she
is able to know her mother and thus to know herself. The "dialogue" of
the voice of the daughter and the fictionally constructed voice of the
mother is modeled on inner dialogue. As Bakhtin asserts, there *can* be
dialogue even when one speaker remains silent. The daughter's words are
formulated with an awareness of the imagined voice of her mother con-
stantly influencing these utterances.

Carolyn Steedman writes, in *Landscape for a Good Woman,* that her
auto/biography is "about the stories we make for ourselves" (5). Modjeska's
text is about stories, mostly made for herself. For many years, her mother's
voice was silenced by the lack of opportunity for mothers to express for-
bidden desires, by abusive mental health care practices as well as her lack
of confidence in her right or ability to speak.

During the final summer of Poppy's life and the final section of Modjeska's
text, she and her daughter engaged in a long conversation, which the daugh-
ter transcribed. This was a time for the daughter to ask the questions and

to get the answers she needed to make sense of her memories. Even this process, however, frustrated the daughter. Poppy's answers were never straightforward or complete. Her voice rambled and lost its direction. It was not until four years later, after Poppy died and Modjeska had time for reflection, that she realized that this language and conversation, with gaps and evasions, was what encouraged her to imagine and to create the story she wanted for herself. She writes of this final conversation with her mother as a gift:

> During the summer we knew would be her last . . . Poppy and I be-gan a conversation which lasted a month and was still incomplete when I left. Nothing she said amounted to the definitive answers I was hoping for. . . . I now think that Poppy's reluctance to give me what I wanted that last summer, talking sporadically, sometimes directly, sometimes elliptically, which I understood at the time as capricious, was on the contrary her last gift. "Use your imagination," she said, not hesitating to use hers. (8, 12)

Conclusion

Both *In My Mother's House* and *Poppy* contain a conversation that is about storytelling and the voices that tell these stories. In each, it is a mother's and daughter's voices that are engaged in such a dialogue. In Chernin's text, the mother tells stories and her daughter records them. Formal appointments were made over a seven-year period to "tell sto-ries" and, thus, record them. This process of capturing or recording the stories, however, changes them. Both the content and the voice change through the process of transmission. Roles change and sometimes mother and daughter "collaboratively" tell and write stories, merging their voices. Because the auto/biography was published in a second revised edition, Chernin is able to write about changes in her mother's voice, captured and fixed in her text, initiated by public readings from the first edition, where her mother was in the audience. Speaking and writing of a voice over time and the changes brought about by the fixing of text, in publi-cation, is uniquely addressed in Chernin's text. All stories transmitted orally have a history of such change and growth, over time, of course. This text examines the related, yet different, process of textual "unfixity" with-in contemporary publication and public reading practices. The reader is given the unique opportunity to watch a mother and daughter live and react to such practices.

Drusilla Modjeska's text is an appropriate one to complete this chap-ter and the readings section of this book. She also engages in a conversa-tion with her mother about storytelling and voice. The mother, whose voice she engages in dialogue taken mostly from her diaries and letters,

is drawn from the daughter's memory as well as her imagination. Modjeska warns her reader, at the beginning of her text, that nothing within "should be taken simply as literal" (317). Instead, the reader is told, she has "created" a voice to have a conversation with, to *talk* to.

Modjeska deconstructs traditional biography, as a genre, as well as "the fictional paradox of truthfulness" (308). Her biographical/autobiographical/fictional text grapples with the issue of the difference or distinction between "evidence," historical fact, and experience versus imagination. Just as the notion of "separation" between the mother's biography and the daughter's autobiography is problematized in all of the texts I have discussed, so is the notion of separation of what is experience and what is imagination in *Poppy*. Modjeska resists dominant literary writing praxis as she questions the notion of "truth" in biography and autobiography. She comments on the value of the lessons she has learned about the "relatedness" of memory and creation. Also, she writes about the value of regarding her mother and her voice as an autonomous voice and subject of her own text. She credits the source of this insight and a new relationship with her mother as a woman to engage in conversation to the experience of writing her story as an artistic creation. Modjeska writes:

> [A]s I write I find that in creating her, in knowing her as separate, no longer the wounded mother, she is given back to me and I draw close in recognition. . . . Perhaps her last gift is simply that: a way of living and of being which has been made possible by reclaiming her and knowing her, in imagination if not in fact, for by doing that I have finally let her go. (139, 312)

My Mother, My Voice

When I was about thirteen years old, a subtle but dramatic shift occurred in my voice. The change was actually the culmination of years of growth and hormonal changes. At twelve and a half, I reached puberty and about the same age or shortly after I attained my adult weight and height. I was certainly aware of the major changes in my body: menstruation and all its discomforts and messiness, oilier skin that was very temperamental, a new slimness that came with my increased height, a softening of my chest to form small breasts (a major disappointment, since my mother was so full-busted), and, thus, an overall change in my body shape and contours. One change that I was not prepared for was a change in the sound of my voice.

My vocal "sound" or voice had never been an important part of my identity. I had no interest in singing or drama activities. Many of my friends took part in church choirs or school glee clubs, but I had no inclination to join such a group, fortunately. Fortunately, that is, because I

did not and do not have any singing talent. Rather, I was very comfortable being part of an extended family, on my mother's side, that had a hard time with "Happy Birthday." None of us could "carry a tune," we joked. My father did have a lovely singing voice. In fact, he made a self-financed recording of his singing as a gift to my mother when he was drafted into the army and sent to the South Pacific. However, I have no memory of his singing because he is, in general, a very quiet man. My discordant singing voice did not displease me, also, because I thought of myself as a dancer, a dancer and a serious student. Singing might be fine for some adolescents, but it simply did not interest me. (I was much older when I discovered opera, which now enthralls me. Here, I am the listener, however.)

I didn't realize my voice had changed, not until I began to have a strangely disconcerting experience. When I answered the telephone in our house, over and over, callers mistook me for my mother. This was happening even when it was my father calling. Eventually this vocal occurrence was so constant that every adult family member and friend, upon hearing my voice, would begin with a question. They would query me, "Who is this?" "Is this Jo?" A few times, in a rush, my aunt or one of my mother's many friends moved forward into conversation so quickly, thinking I was my mother, that it was impossible to stop the flow of words I knew were not intended for my youthful ears.

Being the very introverted and thoughtful adolescent that I was, I worried over this confusion a lot. How tempting it was to act my mother on the phone, to contemplate hearing all the exciting and out of reach adult conversation. I knew it was wrong to trick my mother's callers, but the idea was very attractive. On the other hand, I asked myself, how could I sound like a person who was so much older and had a very different "verbal" personality than I did? My mother is a very gregarious person with many friends. Even at that age I spent more time with books than with friends. My "paper voice," as Kim Chernin calls the written voice, was always a comfortable means of communication for me, even at a young age. I enjoyed writing for school assignments and in a journal starting with my elementary school years. I also spent much of my time lost in thought, in solitude. But, now surprisingly, when I answered the phone, I was taken for a very social adult woman.

As an adult, so much of my relationship with my own mother has been about voice, because the telephone has connected us for thirty years. We see each other in person yearly, but mostly we talk and listen on the telephone. In another time, maybe, we might have written letters. Or, maybe, we would have been lost to each other if we were unable to write. Most of our talk is reporting or chatting from the lap, as Chernin describes. Very, very few stories come from that "place high up on the wall."

I call my mother. We talk about everything and nothing. We talk mostly about very superficial things—the weather, clothing, trips planned, movies seen. Mostly she tells me stories. Sometimes, I close my eyes and just listen. The rhythm, the familiar cadence, the music of her voice make my muscles relax and my breathing slow when I'm very stressed. She is a master storyteller and especially when telling stories to children. I am not the first to be drawn in by her cadences. She has been a preschool teacher for forty years and is still employed. She brings her depth of experience as well as a flair for drama to every storytelling occasion and opportunity. Knowing all this makes me no less susceptible to the charms of her voice.

Today, however, I can sense a subtle shift in my life around the issue of my mother's voice. Now it is hers that is changing, as mine changed when I was thirteen. It is due to age, not ill health. In fact she is very vital and active in a way that many older people can envy. But she sounds older. I don't know much about the physiology of the aging voice, but I'm sure there is a difference. I am very aware of this new sound because it is principally on the telephone that our mother-daughter relationship exists.

The change in my mother's voice has accompanied a very gradual shift in our relationship. I don't look for solace or support from the sound of her voice as much as I did a decade ago. Rather, I feel her needing to hear *my* voice, now, in a new way. I provide some stability and a source of balance for her. Now, I am the established adult who earns a good salary, pays a mortgage, and occupies a position of authority at work and in my community. I can feel, still, the fragility of the young girl inside me, but I show this to my mother much less. Somehow, I have sensed, the needy daughter voice is not right for our conversations anymore. She and our aging relationship requires me to be the adult, not the pretend adult who sounded like her on the telephone. She needs me to be the grown-up woman who others can and do rely on for survival and clearheaded thinking, above all else.

Afterword

> Mother told her secrets to me
> When I rode
> Low in the pocket
> Between her hips.
> —Maya Angelou, *Now Sheba Sings the Song*

In the preceeding pages, I have proposed and developed a new interpretive strategy for reading women's texts: an understanding of the ways in which a feminist Bakhtinian reading of dialogism can work to shed more light on the interaction between mothers' and daughters' voices in autobiographical narratives by women. As a result of this strategy, my study reinvents conventional definitions of genre, specifically autobiography and biography, demonstrating that these forms can enter into complex relations within the space of one narrative event.

I have also examined the mother-daughter relationship in a new way. I have brought together a wide range of women's autobiographies and foregrounded the maternal biographies embedded in these texts, thereby revealing the persistence of the mother's voice in the consciousness of her daughter. By exposing the dialogic processes at work in these autobiographies, I hope to add to the appreciation of how complicated the question of female individuation is.

My book discusses ten texts by women who seem particularly compelled to tell their mothers' stories. Each author is, in fact, able to write her own autobiography only by using a narrative form that contains her mother's story at its core. In this analysis, I have not asserted that these are "essential" narrative strategies that can be found in all women's texts because they are written by women. Rather, I theorize that certain narrative practices have been used to represent marginalized or formerly silenced voices. Because of the historical timing of these texts, the voices of the mothers of these writers, in particular, have hitherto been silenced. I also do not assert that all women's autobiographies use such a strategy. Many, of course, do not. However, there are other examples that could easily have been included in my analysis, such as Annie Ernaux's *A Woman's Story*, Maxine Hong Kingston's *The Woman Warrior*, Jamaica Kincaid's *Lucy*, and Eva Hoffman's *Lost in Translation*.

In my coda, I take the next logical step, as I see it, and question the emphasis on the daughter and her text as the only vehicle for writing a

mother's story. Daughters' texts have been the center of my own analysis as well as that of other theorists and critics. To begin to remedy this bias, I look at some autobiographical texts in which a mother becomes the subject of her own text. I think these examples will multiply as feminist theory and research matures.

I have also included passages from my own autobiographical text, with my mother's text embedded within it, at the periphery of this book. In doing so, I join with many other feminist theorists who have included so-called personal writing in their texts. I have crossed a boundary that seems very arbitrary and limiting, especially in the context of the mother and daughter auto/biographical texts I have discussed. In looking toward the future of feminist writing on women's autobiographical texts, I concur with Sidonie Smith who writes:

> I suspect that we will see more writing that combines the autobiographical with the critical, or rather, writing that refuses to disjoin the personal from the political/intellectual. This is especially so since much current theoretical debate centers on the issue of positionality. Who speaks in the autobiographical text? But also who speaks about the autobiographical text? ("[Female] Subject" 126)

Coda
Babies and Books:
Motherhood and Writing

Since becoming a mother, I was more and more resigned to
permanent confusion.
—Jane Lazarre, *The Mother Knot*

It is time to let mothers have their word.
—Susan Rubin Suleiman, "Writing and Motherhood"

Some women autobiographers are also mothers who write and establish
their identities through their writing. A relatively small number of
women's autobiographical texts contain a speaking subject who speaks
from this position of mother. Adrienne Rich called for an end to the si-
lencing of the story of mother and daughter in 1976, when she published
Of Woman Born. In Rich's words: "This cathexis between mother and
daughter—essential, distorted, misused—is the great unwritten story"
(225). I have shown that since 1976, when Rich's important text ap-
peared, many women, writing as daughters, have broken this silence and
are writing the previously unwritten story into their autobiographical
texts. However, texts that are "sited" in the writer's identity as a mother
are still rare. Where are the texts in which "the voice of the mother" is
not embedded in a daughter's story but is written by the mother herself?
Why has this direct authorization of the mother's narrative and the sound
of the mother's voice been foregrounded by the story of the daughter in
women's autobiographies and the feminist theoretical discussion of
women's autobiographies?

I am a mother. I have given birth to two amazing human beings. My
daughter, Sarah, is a graduate of Smith College, with a degree in women's
studies and a second bachelor's degree in nursing. She now works as a
nurse and manager in an AIDS/HIV unit in a major hospital center. My
son, David, earned a fellowship at Cambridge University after graduat-
ing with a degree in mathematics from Harvard University. He now
writes, as a staff researcher for Worldwatch Institute. They are beauti-
ful, wonderful people. I love them intensely. I am amazed, truly amazed,
by them, their beauty and accomplishments. They are pieces of me; they

somehow came through my body. I "mothered" them, alone for a few years, and then with the help of their father, their day care center, a wonderful school, and many friends and family members. They are now connected to me by telephone, electronic mail, and visits. I live, work, and study, now, amidst a blessing or curse of solitude. It is both, just as mothering, especially when they were babies, was both joy and confusion, both beauty and anger and lack of focus.

My children and my motherhood have never directly entered my academic writing. I have circled this topic, the intersection of motherhood and writing, and, in particular, the writing of autobiographical texts for eight years as a student/scholar of English and American literature and as a feminist. This search has left me still searching. There are no answers yet in the exploration. I and other feminists are just beginning to explore this huge and central experience for many women.

My academic, "professional" writing has always been very separate from my private living, which has included my mothering. I have not entered any official discourse as a mother. On the other hand, my voice has not been silent, not at all. It has appeared, been "heard" in my journal, in letters, and in conversations. Daily tellings to my friends, my mother and sister, and my children are my "private" discourse. I have kept my work and my "life" very separate. However, the "discourse" of this private life often breaks into my work, like Kristeva's "FLASH" (162). But always, in the past, I have put down my book or turned off my computer and dealt with "real life" tasks and problems before resuming my academic work.

In this coda, I use my own experience as a mother as a lens for a discussion of certain women's autobiographies. My topic is that space where babies and books overlap in the lives of some women, as they have in mine. Are motherhood and writing always separate, or is it possible that an unavoidable overlap can produce more than confusion, madness, and silences? Or perhaps writing at a dining room table, surrounded by children and cooking and cleaning implements—as women did in the nineteenth century—or having thoughts of children circling constantly around the quiet space we carve out at our desks continues to produce a different kind of writing?

Susan Rubin Suleiman quotes Julia Kristeva in her epigraph to "Writing and Motherhood": "[Q]ue savons-nous du discours que (se) fait une mère?" (352). Suleiman agrees: "We know very little about the inner discourse of a mother; and as long as our own emphasis . . . continues to be on the-mother-as-she-is-written rather than on the-mother-as-she-writes, we shall continue in our ignorance" (358). In this essay, Suleiman discusses some fascinating examples of writing by women who are mothers, including Phyllis Chesler, Adrienne Rich, Jane Lazarre, Julia Kristeva

and Tillie Olsen. Suleiman organizes these writers into "clusters" based on their descriptions of the effects of motherhood on their writing careers (obstacle or enhancement). The way she "clusters" these texts appeals to me, probably because I like to look for order, especially in areas where confusion is sometimes overwhelming, like in the area of motherhood. Thus, in those moments and days in my life when motherhood appears only as an obstacle to writing, I think of texts by Virginia Woolf, Tillie Olsen, May Sarton, and Adrienne Rich. On other days, my thoughts are about Julia Kristeva and Rich, who write, in some texts, about motherhood as an enhancement for writing and as a source of integration.

Yet a third possibility is to see motherhood as *both* and to look for ways to "bridge" and ultimately live and work on this bridge that can connect a woman writer's work to her motherhood. Jane Lazarre, in *The Mother Knot,* and Ursula K. Le Guin, in "The Fisherwoman's Daughter," describe such connections. Reading these last two texts, especially, has helped me find ways to make sense of my own experience and to avoid an either/or binary conclusion that would reduce the complexity of the issue. Le Guin uses her mother's name changes, based on changes in her marital status, as a symbol of the complexity of some women writers' lives:

> Her maiden name was Theodora Kracaw; her first married name was Brown; her second married name, Kroeber, was the one she used on her books; her third married name was Quinn. This sort of many-namedness doesn't happen to men; it's inconvenient, and yet its very cumbersomeness reveals, perhaps, the being of a woman writer as not one simple thing—the author—but a multiple, complex process of being, with various responsibilities, one of which is her writing. (231)

I have had one name for most of my life. I changed it when I married for the first time, but resumed my father's name eleven years later. Many-namedness is a symbol of a life that resembles a collage. Some mother/writers feel as if their lives resemble collages. I often feel this way. Daily goals are not always clear. All I can say I know for sure today is that being a mother is central to my identity. Reading and writing about literature is equally central.

I read Virginia Woolf's *A Room of One's Own* for the first time in November 1974. My last name was Roodman. I wrote these pieces of autobiographical data on the title page of my copy, which is now falling apart. The pages are turning yellow and are marked up and underlined in red ink. My son was six and my daughter was five when I first read this book. I was commuting ninety miles, twice weekly, to work on my Ph.D. in English at the University of Massachusetts, in Amherst. Literature and feminism were converging for the first time in my life, in a very exciting class in feminist criticism taught by Arlyn Diamond. I was also

teaching in a program for adults that was affiliated with Goddard College. My life was incredibly full, yet overwhelming. I was enthralled with Woolf's text. I felt like she had looked at *my* life and figured it out: I needed my own money and my own room. Of course I was frustrated and angry much of the time. I had neither. My work was going well, but I never had long, uninterrupted spaces of time and quiet to develop my ideas at length.

It is true that Woolf had neither children nor real concerns about daily financial security. She had the space and quiet to write her own exquisitely beautiful pieces of fiction, prose, and autobiography. She was, however, very sensitive to the needs of women with children. She was aware that Shakespeare's sister "never wrote a word" and that "[s]he lives in you and in me, and in many other women who are not here tonight, for they are washing up the dishes and putting the children to bed (117)." I knew after reading *A Room of One's Own* that I had to find my own room and means of support. My children were both in school and day care. They no longer demanded all my energies. However, I still thought about and planned for them, constantly. The relationship didn't define me, but it always dominated. I pushed it to the edges of my thoughts as much as possible. I was doing both—babies and books—but still thinking, perhaps unnecessarily, that life had to follow an either/or paradigm. I concluded that both parts of my life would continue to suffer and that, ultimately, I would have to abandon one. And the world around me reinforced the need for mothering but not the same need for writing. I heard the same voices that Woolf's fictitious woman poet heard: "[W]rite if you choose; it makes no difference to me. The world said with a guffaw, Write? What's the good of your writing?" (54). One year after reading Woolf's text, I abandoned my study and writing and began working at various jobs to gain financial independence. I continued to read and to mother.

Recently, I reread *A Room of One's Own*. Again, I found Woolf's text to be very clear and precisely crafted. Her reasoning is so sound: We all need a room and money in order to write fiction, or to write anything. I now have both. My work is flowing as it never did when my children needed my daily physical labor. But there is a new doubt. Can one write if there is too much silence? What kind of writing comes from solitude? I found something else in Woolf this time. She was aware of the value of community and connections and aware, also, that women have been prepared and educated for writing in common living spaces as well as in their own rooms. She states:

> If a woman wrote, she would have to write in the common sitting-room. And . . . she was always interrupted. . . . Then, again, all the literary training that a woman had in the early nineteenth century was training in the observation of character, in the analysis of emo-

tion. Her sensibility had been educated for centuries by the influences of the common sitting-room. People's feelings were impressed on her; personal relations were always before her eyes. (69–70)

Woolf, however, felt that this preparation was valuable for a writer of fiction, but not for a poet. For her, poetry was an inward, lonely journey toward a solitary self. Nevertheless, she saw a richness in women's family and community connectedness. She experimented with different voices and alternatives to the single authorial, narrative voice in her own writing and tied her use of these innovative practices to her "training" in a large family. (Both Clarissa and Septimus speak as first person narrators in *Mrs. Dalloway,* for example.) Perhaps Virginia Woolf would counsel me to leave the door of my own room ajar and to take frequent breaks.

Tillie Olsen writes with sadness and eloquence of women's silences and about times in their lives when they can't write, because of the deadening burdens associated with the care of children. Her autobiographical text, *Silences,* chronicles several decades in her life when her own writing was eclipsed by the demands of caring for her children, working at jobs to support them, and doing political organizing. Reading Olsen, in the early 1970s and again more recently, was reading about waste in women's lives. Her voice and words needed more space and time. The desire for "seductive babies" represented a passionate struggle for Olsen. Reading her portrayal of this struggle touched me deeply. It was difficult for me to pull away from the physical intoxication of pregnancy, birth, and breast-feeding. These experiences were sensual and gorgeous for me. I did not do much "serious" writing or reading once my son was born. The sheer exhaustion is my strongest memory. After the subsequent birth of my daughter, it took an even longer time to begin thinking and writing again. I had two babies, then, and it was an especially confusing time for me. I read this same confusion and ambivalence about motherhood in Olsen's essay, "Love." She writes:

> The oppression of women is like no other form of oppression. . . .
> It is an oppression entangled through with human love, human need, genuine (core) human satisfactions, identifications, fulfillments. . . .
> (And where there are children. . . . And where there are children. . . .)
> AND YET THE TREE DID—DOES—BEAR FRUIT
>
> (258)

In much of her writing, Olsen describes tremendous obstacles to writing experienced by mothers: Mothers don't write because books and babies don't thrive together. And, yet, as I reread Olsen, I see some open-ended questions in her explorations into the dilemma of the mother-writer. She asks, Is separateness, solitude, and quiet the only life for a woman

writer? And, most importantly, what kind of writing does it produce? She quotes Käthe Kollwitz, from her *Diaries and Letters of Käthe Kollwitz*, on this issue: "[Y]et, formerly, in my so wretchedly limited working time, I was more productive, because I was more sensual; I lived as a human being must live, passionately interested in everything. . . . Potency, potency is diminishing" (212). Olsen also includes a letter written to her from Jane Lazarre, as part of her description of her own quest for answers. Lazarre writes: "The meaning of work, and the need to learn to insistently be an artist in the midst of family is what I am now always trying to understand. . . . There is so much to be written about this motherhood and its hold on us" (211).

After my children both went to college, I resumed my academic work. I read differently now. I have lots of empty rooms and lots of quiet. It is during this more peaceful time of study that I have read Adrienne Rich and Julia Kristeva. My reactions are intense but, also, more abstract and intellectual. Although I have taken a more "academic" approach in my discussion of Rich and Kristeva, which follows, this reading and study have helped me, also, to take the risks I am taking in this essay/coda and to speak with my own autobiographical "I."

Adrienne Rich's *Of Woman Born: Motherhood as Experience and Institution* was an attempt to create a new form of writing. Personal recollections, political analysis, history, myth, and poetry are combined in a collage. In her text, she celebrates the female body and the experience of motherhood. She also issues an oratorical and stirring call to women to reclaim their/our bodies and to wrest control of these from the patriarchal "institution" of motherhood. Her vision is radical and utopian:

> The repossession by women of our bodies will bring far more essential change to human society than the seizing of the means of production by workers. . . . We need to imagine a world in which every woman is the presiding genius of her body. In such a world women will truly create new life, bringing forth not only children (if and as we choose) but the visions, and the thinking, necessary to sustain, console, and alter human existence—a new relationship to the universe. (285–86)

For Rich, female biology, with maternity as a central part of its functions, has political, radical implications. The *institution* of motherhood is the patriarchal system that has disconnected mothers from their bodies. The *experience* of motherhood, with its power, belongs only to women.

For me, some of the most interesting sections in *Of Woman Born* are Rich's attempts to deal with the experience, rather than the institution, of motherhood. Her own maternal experience, as Rich describes it in her text, was frightening in its power and perceived significance. She recalls: "Nothing, to be sure, had prepared me for the intensity of relationship

already existing between me and a creature I had carried in my body and
now held in my arms and fed from my breasts" (35). The focus of this
memory is a mother's experience, rather than a child's. One of the major
themes that recurs in her autobiographical text is her ambivalence, what
she calls a "division within myself" (15). She describes this painful ex-
perience of feeling fiercest anger and love, simultaneously. The mind/body
split is another division in Rich's narrative. Her intellectual life, as a poet,
is in constant opposition to the emotional and physical experience of mater-
nity. As a feminist theorist writing about the experience of motherhood,
she also makes a statement about the ambivalence and division inherent
in this experience, through her choice of language. In her chapter detail-
ing the institution of motherhood, she writes as a cultural feminist and
uses a "textbook" style. In other chapters detailing autobiographical ex-
periences, the writing style and voice is confessional.

Julia Kristeva immigrated to France from Bulgaria in 1966. In the
introduction to *The Kristeva Reader,* Toril Moi writes: "At the age of 25,
. . . equipped with a doctoral research fellowship, [Kristeva] embarked
on her intellectual encounter with the French capital. It would seem that
she took the Left Bank by storm" (1). Her early work in linguistic theory
and the semiotic culminated in *Revolution in Poetic Language.* But three
later works, "Stabat Mater" (1977), "A New Type of Intellectual: The Dissi-
dent" (1977), and "Women's Time" (1979), are, at least in part, concerned
with motherhood and writing. Kristeva's own maternity (her son was born
in 1976) and the completion of her training as a psychoanalyst are linked
chronologically to this shift in her intellectual interests and writing.

"Stabat Mater" was first published a year after *Of Woman Born.* For
both Kristeva and Rich, the experience of motherhood seems to have been
highly problematical and, at the same time, very significant. I note, first,
some similar themes and issues in the two works: one, the splitting or divid-
ing of the self or the subject, which is echoed by a split in the text; two, a
hopeful, utopian agenda that grows out of the experience of motherhood.

"Stabat Mater" is a study of the cult of the Virgin Mary and, at the same
time, a recording of Kristeva's own experience of maternity. The text is
bisected or divided into two pieces that "coexist" on the page. The per-
sonal recollections are in bold-faced print and break into the text begin-
ning with the word "FLASH." There is not a neat dichotomy between
the two texts, however. They "refuse" to remain separate. One of the main
concerns of the combined pieces, as Toril Moi states, is

> to point out that today, due to the demise of the cult of the Virgin,
> and of religion in general, we are left without a satisfactory discourse
> on motherhood. . . . There is, then, an urgent need for a "post-vir-
> ginal" discourse on maternity, one which ultimately would provide
> both women and men with a new ethics: a "herethics." (160–61)

Kristeva's text is more obviously bisected than Rich's, yet the duality is not a neat one. The historical writing, the autobiographical telling, and the development of her new scheme of ethics, which would usher in her notion of an "ideal" future, overlap and cross the boundaries established by the columns of type. Her attempts at dealing with the problematic that motherhood represents, for her, are no more conclusive than Rich's. There is deeply felt and expressed ambivalence in both texts. In passages such as those that follow, Kristeva attempts to describe this feeling: "My body is no longer mine, it doubles up, suffers, bleeds" (167); "[T]he dark area that motherhood constitutes for a woman" (179); "Let us call 'maternal' the ambivalent principle that is bound to the species" (161–62).

Maternity for Kristeva is also a metaphor for the place where multiple boundaries exist. A woman as mother is "a strange fold" in the human fabric that tightly pulls on the connections between nature and culture, inside and outside, the semiotic and the symbolic, self and other (182). However, for Kristeva, the split of a female subject that occurs in maternity yields a "productive" psychotic experience, an experience of love for another, unlike any other experience. She presents her theory of herethics, at the conclusion of "Stabat Mater," as a hopeful new beginning, for both men and women, through a new kind of ethics and morality. Women and mothers, in particular, will provide the basis for the new ethics from their experience of split subjectivity. Rather than utopian, her vision is of possibility and love. She writes:" *[H]erethics, is perhaps no more than that which in life makes bonds, thoughts, and therefore the thought of death, bearable: herethics is undeath [a-mort], love*" (185).

If Kristeva sees the female as the "principal metaphor" for difference, perhaps maternity can be seen as a metaphor for ambivalence. The splitting of the human subject forms the basis for this metaphor. Maternity is the only human experience that includes both enlargement, from one being to two, within one, and diminishment, from two beings to one. Domna Stanton, in her article "Difference on Trial," also describes this phenomenon: "This essential capacity to give life/love to another in another way is concretized through the metaphor of the pregnant body . . . the uniquely maternal experience of arrival, issue *(sortie),* and separation" (168). And further, if the female is a metaphor for the unknowable or unpresentable, maternity also represents conflicts within this unknowable.

Ambivalence is a continual oscillation (as between one thing and its opposite) or fluctuation. The roots of the word are *ambi,* meaning both, on both sides, around, and *valence,* meaning the relative capacity to unite, react, or interact, the degree of combining power. This continual oscillation is seen in both Rich's and Kristeva's autobiographical texts. Rich's maternity is a metaphor for valence between love and hate, the autobiographical and the theoretical voice, the self and the other. For Kristeva,

the maternal experience is life as both, on both sides, around. It is ambiva-
lence: "It is an identity, that splits, turns in on itself and changes without
becoming other" (297).

In this coda, I have spoken to you in two very different voices. One voice
uses personal pronouns, I and me, and talks of feelings and memories and,
also, rambles when she writes. The other is my theoretical voice. It is more
organized, cool, and dispassionate. Also, I have, I realize, deconstructed
my own model and plan. I prepared the way for a distinct division, a dia-
logic argument between two opposing points of view about the relation-
ship between motherhood and writing. The categories have overlapped
and, finally, disappeared.

I have come to no new conclusions. All I have are different questions.
Is writing better with much solitude, quiet, and peace? And, if it is, what
is the cost? What are the choices that would give mother/writers both
peace and connection and would, perhaps, lead to a different kind of
writing? What will this writing look like? Will it be many-voiced, with
photographs, poetry, and jokes?

Birth
The doctor
was so surprised,
He passed away.

In the spasms of birth
He looked up my cunt
And screamed—
 Oh my God
 There's nothing there
 But a slim volume of verse!!
 —Sue Mullins, *Woman: An Issue*

Epilogue

In the concluding sentences of *The Mother/Daughter Plot,* Marianne Hirsch begins to explore the problematic of mothers and daughters in a very provocative way. In this discussion of women's voices speaking and being heard, she writes: "The greatest tragedy that can occur between mother and daughter is when they cease being able to speak and to listen to one another. But what if they inhabit the same body, what if they are the same person, speaking with two voices?" (199). I read this concluding sentence to her book and felt angry. Why did she stop with this fertile assertion? Where might this query lead? My own possible answers are many. This mother/daughter-inhabiting-one-body might be an excellent metaphor for women's autobiographical texts with embedded maternal narratives. It could also be a basis for theoretical discussions of such texts. Or it could be a meta-monster or a science fiction character. Or it could be ME. I am always both, trying to speak and understand as the daughter of a mother and the mother of a daughter. In this writing of a theoretical and textual analysis of a particular group of women's autobiographies, I also speak and write as an autobiographical subject of a text. In addition, my own narrative voice, here, is the joining of two voices. My own daughter/mother/ daughter narrative is not either/or but both/and, as well as something that is a monstrous inseparability. How and when is my voice joined with that of the woman/daughter who was contained within me and fed by my body *and* that of the woman/mother whose body once contained mine? Which subject position do I speak which parts of my story from? Are there answers to these questions, or are there only ever more questions?

Notes
Works Consulted
Index

Notes

1. Introduction

1. See Carolyn Steedman, "Biographical Questions, Fictions of the Self," *Childhood, Culture and Class in Britain: Margaret McMillen, 1860–1931* (London: Virago, 1990) 243–59; Bella Brodzki, "Mothers, Displacement, and Language in the Autobiographies of Nathalie Sarraute and Christa Wolf," *Life/Lines: Theorizing Women's Autobiography* (Ithaca: Cornell UP, 1988) 243–59; Susan S. Lanser, "Toward a Feminist Narratology," *Feminisms: An Anthology of Literary Theory and Criticisms*, ed. Robyn R. Warhol and Diane Price Herndl (New Brunswick: Rutgers UP, 1991) 610–27.

2. I discuss Kristeva's "Stabat Mater" in a later chapter. I use Adrienne Rich's *Of Woman Born* as an important feminist theoretical text about the institution and the experience of motherhood also.

3. See especially Judith Butler, *Gender Trouble: Feminism and the Subversion of Identity* (New York: Routledge, 1990); and Denise Riley, *"Am I That Name?" Feminism and the Category of "Women" in History* (Minneapolis: U of Minnesota P, 1988).

4. Lejeune theorizes that the difference between identity and resemblance in referential texts is an important distinction between autobiography and biography. He describes the existence of a historical "model" outside of the text and then places this "model" in a formula that schematically represents biography versus autobiography:

> *Biography:* A is or is not N; P resembles M.
> *Autobiography:* N is to P as A is to M.
> (A = author; N = narrator; P = protagonist; M = model)
> Since autobiography is a referential genre, it is naturally subject
> at the same time to the order of resemblance at the level of the model,
> but this is only a secondary characteristic. (25)

5. Mae Gwendolyn Henderson notes that Bakhtin's social groups "are designated according to class, religion, generation, region and profession." Her interpretation of his theory extends these categories to include "race and gender . . . absent in Bakhtin's original system of social and linguistic stratification" (139).

6. Also, see Susan Rubin Suleiman, "Writing and Motherhood," *The M(o)ther Tongue: Essays in Feminist Psychoanalytic Interpretation*, eds. Shirley Nelson Garner et al. (Ithaca: Cornell UP, 1985) 352–77.

2. Conversations about Space and Houses

1. Her father was technically born an Indian, although Suleri describes him as "'Pakistani' before Pakistan" (115). Her father's country *was* called Pakistan before 1947 by a small group of expatriate Muslim Indian intellectuals, but it did not "officially" exist until the Raj collapsed and the British divided India into two nations. The Civil War of 1971 further changed the boundaries of Pakistan when part of the country became Bangladesh.

2. For texts that *are* narratives of the dying days of the mother, those Nancy K. Miller calls *"memoirs of a dying other,"* or discussions of such narratives, see Simone de Beauvoir, *A Very Easy Death,* trans. Patrick O'Brian (New York: Putnam, 1966); Nancy K. Miller, "Autobiographical Deaths," *Massachusetts Review* (1992): 19–47 and "Presidential Forum: Facts, Pacts, Acts," *Profession* 92 (1992): 10–14.

3. For a fuller discussion of this passage, see Sidonie Smith, *Subjectivity, Identity, and the Body* (Bloomington: Indiana UP, 1993) 87–88.

4. See Sidonie Smith for a complete analysis of the "history of the body informing Woolf's 'Sketch'" (*Subjectivity* 87).

5. Woolf's life was an especially indoor one, as she describes it in her text. Also, all women at that time had much less access to the exterior professional world and to travel than Suleri does, today, as a world traveler.

6. See Carolyn G. Heilbrun, *The Last Gift of Time* (New York: Dial, 1997); May Sarton, *Journal of a Solitude* (New York: Norton, 1973); *Plant Dreaming Deep* (New York: Norton, 1968); *At Seventy* (New York: Norton, 1984); and Alix Kates Shulman, *Drinking the Rain* (New York: Penguin, 1996).

3. Conversations about Intimacy, Bodies, and Sexuality

1. I am indebted to Victoria Boynton for this use of the word "site." Victoria Boynton, "Sexiting Ethos: Women Speakers in Recent North American Writing," diss., Binghamton U, 1994.

2. Lorde died in St. Croix, U.S. Virgin Islands, where she was then living, of breast cancer, on November 17, 1992. She was fifty-eight.

4. Conversations about Material Things, Longing, and Envy

1. For another example of women's use of clothing in order to "pass" for a "higher" economic class, see Natashe Saje's poem "Dress Code." She describes herself as a "middle manager's / daughter, whose family toiled / its way up the ladder: slipping / down is just a spot of grease away." *Women's Review of Books* (November 1994): 26.

2. After publication of *Bastard out of Carolina,* Allison published *Two*

or Three Things I Know for Sure. This text further reinforces the evidence of autobiographical sources for her text and for her protagonist, Bone.

3. She was still writing the same story in *Two or Three Things I Know for Sure*, which Allison says, in the author's note that ends her text, "was written for performance in the months following completion of my novel, *Bastard out of Carolina*." She later revised it, adding family photographs, for publication.

4. Steedman describes a similar compulsion to have the stories of her family appear in books rather than ahistorical descriptions of stock creatures who represent all poor and working-class people. She writes: "[T]he point is *not* to say that all working-class childhoods are the same . . . so that the people in exile, the inhabitants of the long streets, may start to use the autobiographical 'I,' and tell the stories of their life" (*Landscape* 16).

5. "I remember Mama sitting at the kitchen table in the early morning, tears in her eyes, lying to me and my sister, promising us that the time would come when she would leave him. . . . I think about her sitting there now, waiting for him to wake up and want his coffee. . . . Sometimes I hate my mama" (*Trash* 44).

6. "But the idea that anything could touch my mother, that anything would dare to hurt her was impossible to bear, and I woke up screaming the one night I dreamed of her death. . . . I thought of my mama like a mountain or a cave, a force of nature . . ." (*Trash* 35).

7. "I don't think the baggage will ever lighten for me or my sister. We were born, and had no choice in the matter; but we were burdens, expensive, never grateful enough. There was nothing we could do to pay back the debt of our existence. 'Never have children, dear,' she said. 'They ruin your life'" ("Landscape" 31).

8. In 1996, I changed this pattern by buying a house. My experience is described in chapter 2.

5. Conversations about Storytelling and Voice

1. There is an earlier photo included as a frontispiece to the edition, before the title page. It is also done in a studio and depicts the "Chernin Family, Russia c. 1911." It is a photo of Perle Chernin and her three daughters. She is holding the youngest girl.

2. Family photographs as auto/biography are also the subject of Marianne Hirsch's *Family Frames: Photography, Narrative and Postmemory* and Annette Kuhn's *Family Secrets: Acts of Memory and Imagination*.

3. Modjeska's text, however, contains no actual photographs. It is, in fact, a "picture book" without pictures/photographs. Rather, family photographs are a central subject of the text's narrative.

Works Consulted

Aiken, Susan Hardy. *Isak Dinesen and the Engendering of Narrative*. Chicago: U of Chicago P, 1990.

Alarcón, Norma. "Interview with Cherríe Moraga." *Third Woman* (1986): 127–34.

Allison, Dorothy. *Bastard out of Carolina*. New York: Dutton, 1992.

———. "The Exile's Return: How a Lesbian Novelist Found Her Way into the Mainstream." *New York Times Book Review* 26 June 1994: 15–16.

———. "Telling a Mean Story: Amber Hollibaugh Interviews Dorothy Allison." *Women's Review of Books* (July 1992): 16.

———. *Trash*. Ithaca: Firebrand, 1988.

———. *Two or Three Things I Know for Sure*. New York: Dutton, 1995.

Anderson, Linda. "At the Threshold of the Self: Women and Autobiography." *Women's Writing: A Challenge to Theory*. Ed. Moira Monteith. Sussex: Harvester P, 1986. 54–71.

Ashley, Kathleen, Leigh Gilmore, and Gerald Peters, eds. *Autobiography and Postmodernism*. Amherst: U of Massachusetts P, 1994.

Atwood, Margaret. *The Robber Bride*. New York: Talese/Doubleday, 1993.

Bachelard, Gaston. *The Poetics of Space*. Trans. Maria Jolas. Boston: Beacon, 1969.

Bakhtin, M. M. *Art and Answerability: Early Philosophical Essays by M. M. Bakhtin*. Ed. Michael Holquist and Vadim Liapunov. Trans. and notes Vadim Liapunov. Supplement trans. Kenneth Brostrom. Austin: U of Texas P, 1990.

———. *The Dialogic Imagination: Four Essays*. Ed. Michael Holquist. Trans. Caryl Emerson and Michael Holquist. Austin: U of Texas P, 1981.

——— [V. N. Vološinov]. *Marxism and the Philosophy of Language*. Trans. Ladislav Matejka and I. R. Titunik. New York: Seminar, 1973.

———. *Problems of Dostoevsky's Poetics*. Ed. and trans. Caryl Emerson. Intro. Wayne C. Booth. Minneapolis: U of Minnesota P, 1984.

Barker-Nunn, Jeanne. "Telling the Mother's Story: History and Connection in the Autobiographies of Maxine Hong Kingston and Kim Chernin." *Women's Studies* (1987): 55–63.

Bauer, Dale M. *Feminist Dialogics: A Theory of Failed Community*. Albany: State U of New York P, 1988.

Bauer, Dale M., and S. Jaret Mckinsky, eds. *Feminism, Bakhtin, and the Dialogic*. Albany: State U of New York P, 1991.

Beauvoir, Simone de. *A Very Easy Death*. Trans. Patrick O'Brian. New York: Putnam, 1966.

Bell, Susan Groag, and Marilyn Yalom, eds. *Revealing Lives: Autobiography, Biography and Gender*. Albany: State U of New York P, 1990.

Benstock, Shari, ed. *The Private Self: Theory and Practice of Women's Autobiographical Writing*. Chapel Hill: U of North Carolina P, 1988.

Bordo, Susan. *Unbearable Weight: Feminism, Western Culture, and the Body.* Berkeley: U of California P, 1993.

Boynton, Victoria. "Sexiting Ethos: Women Speakers in Recent North American Writing." Diss. Binghamton U, 1994.

Bristow, Joseph. "Life Stories: Carolyn Steedman's History Writing." *New Formations* (Spring 1991): 113–31.

Brodzki, Bella. "Mothers, Displacement, and Language in the Autobiographies of Nathalie Sarraute and Christa Wolf." Brodzki and Schenck 243–59.

Brodzki, Bella, and Celeste Schenck, eds. *Life/Lines: Theorizing Women's Autobiography.* Ithaca: Cornell UP, 1988.

Broner, E. M. *Her Mothers.* New York: Holt, 1975.

Broughton, Trev, Lynn Broughton, and Linda Anderson, eds. *Women's Lives/Women's Times: New Essays on Auto/Biography.* Albany: State U New York P, 1997.

Bryson, Valerie. *Feminist Political Theory: An Introduction.* London: Macmillan, 1992.

Butler, Judith. *Gender Trouble: Feminism and the Subversion of Identity.* New York: Routledge, 1990.

Cavendish, Margaret. *The Lives of William Cavendish, Duke of Newcastle, and of His Wife, Margaret, Duchess of Newcastle. Written by the Thrice Noble and Illustrious Princess, Margaret, Duchess of Newcastle.* Ed. Mark Antony Lower. London: J. R. Smith, 1872.

Chernin, Kim. *The Hunger Song.* London: Menard, 1982.

———. *The Hungry Self: Women, Eating and Identity.* New York: Harper 1986.

———. *In My Mother's House.* New York: Harper, 1994.

Chodorow, Nancy. "Family Structure and Feminine Personality." *Woman, Culture, and Society.* Ed. Michelle Zimbalist Rosaldo and Louise Lamphere. Stanford: Stanford UP, 1974. 43–66.

Cixous, Hélène. "The Laugh of the Medusa." Trans. Keith Cohen and Paula Cohen. *New French Feminisms.* Ed. Elaine Marks and Isabelle de Courtivron. New York: Schocken, 1981. 245–64.

Cochran, Jo Whitehorse, Donna Langston, and Carolyn Woodward, eds. *Changing Our Power: An Introduction to Women Studies.* 2nd ed. Dubuque, IA: Kendall/Hunt, 1991.

Culley, Margo, ed. *American Women's Autobiography: Fea(s)ts of Memory.* Madison: U of Wisconsin P, 1992.

Daly, Brenda O., and Maureen T. Reddy, eds. *Narrating Mothers.* Knoxville: U of Tennessee P, 1991.

Danow, David K. *The Thought of Mikhail Bakhtin: From Word to Culture.* New York: St. Martin's, 1991.

Davies, Carole Boyce. "Collaboration and the Ordering Imperative in Life Story Production." Smith and Watson, *De/Colonizing* 3–19.

Dentith, Simon. *Bakhtinian Thought: An Introductory Reader.* London: Rutledge, 1995.

DiBernard, Barbara. "*Zami*: A Portrait of an Artist as a Black Lesbian." *Kenyon Review* (1991): 195–213.

Dinesen, Isak. *Out of Africa and Shadows on the Grass.* 1938. New York: Vintage Books, 1985.

Donovan, Josephine. *Feminist Theory: The Intellectual Traditions of American Feminism.* New York: Continuum, 1992.

Eakin, John Paul. *Fictions in Autobiography: Studies in the Art of Self-Invention.* Princeton: Princeton UP, 1985.

Edwards, Lee R., Mary Heath, and Lisa Baskins, eds. *Woman: An Issue.* Boston: Little, 1972.

Edwards, Rosalind. *Mature Women Students: Separating or Connecting Family and Education.* London: Taylor and Francis, 1993.

Ernaux, Annie. *A Woman's Story.* Trans. Tanya Leslie. London: Quartet, 1990.

Felski, Rita. *Beyond Feminist Aesthetics: Feminist Literature and Social Change.* Cambridge: Harvard UP, 1989.

Gagnier, Regenia. "Review Essay: Feminist Autobiography in the 1980's." *Feminist Studies* (1991): 135–48.

Garner, Shirley Nelson, et al., eds. *The M(o)ther Tongue: Essays in Feminist Psychoanalytic Interpretation.* Ithaca: Cornell UP, 1985.

Gilligan, Carol, Janie Victoria Ward, and Jill McLean Taylor, eds. *Mapping the Moral Domain: A Contribution of Women's Thinking to Psychological Theory and Education.* Cambridge: Ctr. for the Study of Gender, Educ. and Hum. Dev., 1988.

Gilmore, Leigh. *Autobiographics: A Feminist Theory of Women's Self-Representation.* Ithaca: Cornell UP, 1994.

Gloversmith, Frank, ed. *The Theory of Reading.* Sussex: Harvester, 1984.

Griffin, Gail B. "Braving the Mirror: Virginia Woolf as Autobiographer." *Biography: An Interdisciplinary Quarterly* (Spring 1981): 108–18.

Grosz, Elizabeth. *Jacques Lacan: A Feminist Introduction.* London: Rutledge, 1990.

Heilbrun, Carolyn G. *The Last Gift of Time.* New York: Dial, 1997.

Henderson, Mae Gwendolyn. "Speaking in Tongues: Dialogics, Dialectics, and the Black Woman Writer's Literary Tradition." *Reading Black, Reading Feminist: A Critical Anthology.* Ed. Henry Louis Gates, Jr. New York: Penguin, 1990. 116–42.

Hermann, Anne. *The Dialogic and Difference: "An/Other Woman" in Virginia Woolf and Christa Wolf.* New York: Columbia UP, 1989.

Hirsch, Marianne. *Family Frames: Photography, Narrative, and Postmemory.* Cambridge: Harvard UP, 1997.

———. *The Mother/Daughter Plot: Narrative, Psychoanalysis, Feminism.* Bloomington: Indiana UP, 1989.

———. "Mothers and Daughters: Review Essay." *Signs: Journal of Women in Culture and Society* (Autumn 1981): 200–222.

Ho, Wendy. "Mother/Daughter Writing and the Politics of Race and Sex in Maxine Hong Kingston's *The Woman Warrior.*" *Asian Americans: Comparative and Global Perspectives.* Ed. Shirley Hune et al. Pullman: Washington State UP, 1991.

Hoffman, Eva. *Lost in Translation: A Life in a New Language.* New York: Penguin, 1990.

Hohne, Karen, and Helen Wussow, eds. *A Dialogue of Voices: Feminist Literary Theory and Bakhtin.* Minneapolis: U of Minnesota P, 1994.

Hollibaugh, Amber. "In the House of Childhood." *Women's Review of Books* (July 1992): 15.

Homans, Margaret. *Bearing the Word: Language and Female Experience in Nineteenth-Century Women's Writing.* Chicago: U of Chicago P, 1986.

hooks, bell. *Yearning: Race, Gender and Cultural Politics.* Boston: South End, 1990.

Humm, Maggie. *The Dictionary of Feminist Theory.* New York: Harvester Wheatsheaf, 1989.

Irigaray, Luce. "And the One Doesn't Stir Without the Other." Trans. Hélène Vivienne Wenzel. *Signs: Journal of Women in Culture and Society* (1981): 60–66.

Jouve, Nicole Ward. *White Woman Speaks with Forked Tongue: Criticism as Autobiography.* London: Routledge, 1991.

Juhasz, Suzanne. "Maxine Hong Kingston: Narrative Technique and Female Identity." *Contemporary American Women Writers: Narrative Strategies.* Ed. Catherine Rainwater and William J. Scheick. Lexington: U of Kentucky P, 1985.

Kanoff, Ilene. "The Women's Treatment Program at McLean Hospital: 'Self-in-Relation' Theory into Practice?" *Sojourner: The Women's Forum* (March 1994): 16–17H.

Kristeva, Julia. *The Kristeva Reader.* Ed. Toril Moi. New York: Columbia UP, 1986.

Kritzman, Lawrence D. "Autobiography: Readers and Texts." *Dispositio: Revista Hispánica de Semiótica Literia* (1979): 117–21.

Kuhn, Anna K. "The Failure of Biography and the Triumph of Women's Writing: Bettina von Arnim's *Die Gunderode* and Christa Wolf's *The Quest for Christa T.*" *Revealing Lives: Autobiography, Biography and Gender.* Ed. Susan Groag Bell and Marilyn Yalom. Albany: State U of New York P, 1990. 13–28.

Kuhn, Annette. *Family Secrets: Acts of Memory and Imagination.* London: Verso, 1995.

Lanser, Susan S. "Toward a Feminist Narratology." *Feminisms: An Anthology of Literary Theory and Criticisms.* Ed. Robyn R. Warhol and Diane Price Herndl. New Brunswick: Rutgers UP, 1991. 610–27.

Lauter, Paul. "Working-Class Women's Literature—An Introduction to Study." *Radical Teacher* (March 1980): 16–26.

Lazarre, Jane. *The Mother Knot.* New York: McGraw, 1976.

Le Guin, Ursula K. "The Fisherwoman's Daughter." *Dancing at the Edge of the World.* New York: Grove, 1989. 212–37.

Lejeune, Phillipe. *On Autobiography.* Ed. and Fwd. Paul John Eakin. Trans. Katherine Leary. Minneapolis: U of Minneapolis P, 1989.

Lim, Shirley Geok-lin. "Asian American Daughters Rewriting Asian Maternal Texts." *Asian Americans: Comparative and Global Perspectives.* Ed. Shirley Hune et al. Pullman: Washington State UP, 1991.

Lim, Shirley Geok-lin, and Amy Ling, eds. *Reading the Literature of Asian America.* Philadelphia: Temple UP, 1992.

Lorde, Audre. *Zami: A New Spelling of My Name: A Biomythography.* Trumansburg, NY: Crossing, 1983.

Mairs, Nancy. *Voice Lessons: On Becoming a (Woman) Writer.* Boston: Beacon, 1994.

Marcus, Laura. "'Enough About You, Let's Talk About Me': Recent Autobiographical Writing." *New Formations* (Spring 1987): 77–94.

McCracken, LuAnn. "'The Synthesis of My Being': Autobiography and the Re-

production of Identity in Virginia Woolf." *Tulsa Studies in Women's Literature* (Spring 1991): 59–78.

Meese, Elizabeth A. *(Ex)tensions: Refiguring Feminist Criticism.* Urbana: U of Illinois P, 1990.

Mens-Verhulst, Janneke van, Karlein Schreurs, and Liesbeth Woertman, eds. *Daughtering and Mothering: Female Subjectivity Reanalyzed.* London: Routledge, 1993.

Miller, Jean Baker. *Toward a New Psychology of Women.* 2nd ed. Boston: Beacon, 1986.

Miller, Nancy K. "Autobiographical Deaths." *Massachusetts Review* (1992) 19–47.

———. *Bequest and Betrayal: Memoirs of a Parent's Death.* New York: Oxford UP, 1996.

———. *Getting Personal: Feminist Occasions and Other Autobiographical Acts.* New York: Routledge, 1991.

———. "Presidential Forum: Facts, Pacts, Acts." *Profession* 92 (1992): 10–14.

Modjeska, Drusilla. *Poppy.* Victoria, Australia: McPhee Gribble, 1990.

Moraga, Cherríe. *Loving in the War Years: lo que nunca pasó por sus labios.* Boston: South End, 1983.

Nestle, Joan. *A Restricted Country.* Ithaca: Firebrand, 1987.

Neuman, Shirley. "'Your Past . . . Your Future': Autobiography and Mothers' Bodies." *Genre, Trope, Gender: Critical Essays by Northrop Frye, Linda Hutcheon, Shirley Neuman.* Ed. Barry Rutland. Ottawa: Carleton UP, 1992.

Nice, Vivien E. *Mothers and Daughters: The Distortion of a Relationship.* New York: St. Martin's, 1992.

Olds, Sharon. *Satan Says.* Pittsburgh: U of Pittsburgh P, 1980.

Olney, James, ed. *Autobiography: Essays Theoretical and Critical.* Princeton: Princeton UP, 1980.

———. *Studies in Autobiography.* Oxford: Oxford UP, 1988.

Olsen, Tillie. *Silences.* New York: Delacorte/Seymour Lawrence, 1965.

Perreault, Jeanne. "'That the Pain Not Be Wasted': Audre Lorde and the Written Self." *a/b: Auto/Biography Studies* (1988): 1–14.

Rabinowitz, Paula. *Labor and Desire: Women's Revolutionary Fiction in Depression America.* Chapel Hill: U of North Carolina P, 1991.

Raynaud, Claudine. "'A Nutmeg Nestled Inside Its Covering of Mace': Audre Lorde's *Zami.*" Brodzki and Schenck 221–42.

Rich, Adrienne. "Compulsory Heterosexuality and Lesbian Existence." *Signs: Journal of Women in Culture and Society* (1980): 631–60.

———. *Of Woman Born: Motherhood as Experience and Institution.* New York: Norton, 1986.

Riley, Denise. *"Am I That Name?" Feminism and the Category of "Women" in History.* Minneapolis: U of Minnesota P, 1988.

Rosenman, Ellen Bayuk. *The Invisible Presence: Virginia Woolf and the Mother-Daughter Relationship.* Baton Rouge: Louisiana State UP, 1986.

Saje, Natashe. "Dress Code." *Women's Review of Books* (November 1994): 26.

Sarton, May. *At Seventy: A Journal.* New York: Norton, 1984.

———. *Journal of a Solitude.* New York: Norton, 1973.

———. *Plant Dreaming Deep*. New York: Norton, 1968.

Sedgwick, Eve Kosofsky. *Epistemology of the Closet*. Berkeley: U of California P, 1990.

Shulman, Alix Kates. *Drinking the Rain*. 2nd ed. New York: Penguin, 1996.

Sielke, Sabine. *Fashioning the Female Subject: The Intertextual Networking of Dickinson, Moore, and Rich*. Ann Arbor: U of Michigan P, 1997.

Silvermarie, Sue. "The Motherbond." *Women: A Journal of Liberation* 4.1 (1974): 26–27.

Sister of the Road: The Autobiography of Box-Car Bertha. As Told to Dr. Ben L. Reitman. 1937. Rpt. as *Boxcar Bertha: An Autobiography*. New York: Amok, 1990.

Slade, Carole. "A Definition of Mystical Autobiography." *a/b: Auto/Biography Studies* (1991): 226–39.

Smiley, Jane. *A Thousand Acres*. New York: Fawcett Columbine, 1991.

Smith, Barbara. "Home." *Home Girls: A Black Feminist Anthology*. Ed. Barbara Smith. New York: Kitchen Table/Women of Color, 1983. 64–69.

Smith, Paul. *Discerning the Subject*. Minneapolis: U of Minnesota P, 1988.

Smith, Sidonie. "The Autobiographical Manifesto: Identities, Temporalities, Politics." *Autobiography and Questions of Gender*. Ed. Shirley Neuman. London: Cass, 1991. 186–212.

———. "The [Female] Subject in Critical Venues: Poetics, Politics, Autobiographical Practices." *a/b: Auto/Biography Studies* (1991): 109–30.

———. *A Poetics of Women's Autobiography: Marginality and the Fictions of Self-Representation*. Bloomington: Indiana UP, 1987.

———. "Re-citing, Re-siting, and Re-sighting Likeness: Reading the Family Archive in Drusilla Modjeska's *Poppy*, Donna Williams' *Nobody Nowhere*, and Sally Morgan's *My Place*." *Modern Fiction Studies* (1994): 509–42.

———. "Self, Subject, and Resistance: Marginalities and Twentieth-Century Autobiographical Practice." *Tulsa Studies in Women's Literature* (Spring 1990): 11–24.

———. *Subjectivity, Identity, and the Body: Women's Autobiographical Practices in the Twentieth Century*. Bloomington: Indiana UP, 1993.

———. "Who's Talking/Who's Talking Back? The Subject of Personal Narrative." *Signs: Journal of Women in Culture and Society* (Winter 1993): 392–407.

Smith, Sidonie, and Julia Watson, eds. *De/Colonizing the Subject: The Politics of Gender in Women's Autobiography*. Minneapolis: U of Minnesota P, 1992.

———, eds. *Women, Autobiography, Theory: A Reader*. Madison: U of Wisconsin P, 1998.

Stanley, Liz. *The Auto/biographical I: The Theory and Practice of Feminist Auto/biography*. Manchester: Manchester UP, 1992.

Stanton, Domna C. "Difference on Trial: A Critique of the Maternal Metaphor in Cixous, Irigaray, and Kristeva." *The Poetics of Gender*. Ed. Nancy K. Miller. New York: Columbia UP, 1986.

Steedman, Carolyn. "Biographical Questions, Fictions of the Self." *Childhood, Culture and Class in Britain: Margaret McMillen, 1860–1931*. London: Virago, 1990. 243–59.

———. "Landscape for a Good Woman." *Past Tenses: Essays on Writing, Autobiography and History*. London: Rivers Oram, 1992. First published in *Truth,*

Works Consulted

Dare or Promise: Girls Growing up in the 1950's, ed. Liz Heron (London: Virago, 1985), 103–26.

———. *Landscape for a Good Woman: A Story of Two Lives.* New Brunswick: Rutgers UP, 1991.

———. *Past Tenses: Essays on Writing, Autobiography and History.* London: Rivers Oram, 1992.

———. *The Tidy House.* London: Virago, 1982.

Sternbach, Nancy Saporta. "'A Deep Racial Memory of Love': The Chicana Feminism of Cherríe Moraga." *Breaking Boundaries.* Ed. Asunción Horno-Delgado et al. Amherst: U of Massachusetts P, 1989. 48–61.

Stewart, Veronica. "Mothering a Female Saint: Susan Warner's Dialogic Role in *The Wide, Wide World.*" *Essays in Literature* (1995): 59–73.

———. "The Wild Side of *The Wide, Wide World.*" *Legacy* (1994): 1–16.

Stimpson, Catherine R. Foreword. *Isak Dinesen and the Engendering of Narrative.* By Susan Hardy Aiken. Chicago: U of Chicago P, 1990. i–xi.

Suleiman, Susan Rubin. "Writing and Motherhood." Garner et al. 352–77.

Suleri, Sara. *Meatless Days.* Chicago: U of Chicago P, 1991.

———. "Woman Skin Deep: Feminism and the Postcolonial Condition." *Critical Inquiry* (1992): 756–69.

Tokarczyk, Michelle M., and Elizabeth A. Fay, eds. *Working-Class Women in the Academy: Laborers in the Knowledge Factory.* Amherst: U of Massachusetts P, 1993.

Tong, Rosemarie. *Feminist Thought: A Comprehensive Introduction.* Boulder: Westview, 1989.

Umpierre, Luz María. "Interview with Cherríe Moraga." *The Americas Review: A Review of Hispanic Literature and Art of the USA* (1986): 54–67.

Vozenilek, Helen, ed. *Loss of the Ground-Note: Women Writing about the Loss of Their Mothers.* San Diego: Clothespin Fever, 1992.

Walters, Suzanna Danuta. *Lives Together/Worlds Apart: Mothers and Daughters in Popular Culture.* Berkeley: U of California P, 1992.

Warley, Linda. "Assembling Ingredients: Subjectivity in *Meatless Days.*" *a/b: Auto/Biography Studies* (1992): 107–23.

Watson, Julia. "Unspeakable Differences: The Politics of Gender in Lesbian and Heterosexual Women's Autobiographies." Smith and Watson, *De/Colonizing* 139–68.

Wenzel, Hélène Vivienne. "Introduction to Luce Irigaray's 'And the One Doesn't Stir Without the Other.'" *Signs: Journal of Women in Culture and Society* (1981): 56–59.

White, Allon. "Bakhtin, Sociolinguistics and Deconstruction." Gloversmith 123–46.

Wilson, Elizabeth. "Review: A Restricted Country." *Feminist Review* (1988): 112–14.

Woolf, Virginia. *Moments of Being.* 1976. Ed. Jeanne Schulkind. New York: Harcourt, 1985.

———. *A Room of One's Own.* 1929. New York: Harcourt, 1957.

Woolfe, Sue. *Leaning Towards Infinity: How My Mother's Apron Unfolds into My Life.* Boston: Faber, 1996.

Yarbro-Bejarno, Yvonne. "Chicana Literature from a Chicana Feminist Perspec-

tive." *Chicana Creativity and Criticism: Charting New Frontiers in American Literature.* Ed. María Viramontes. Houston: Arte Publico, 1988. 139–45.

Yeo, Stephen. "Difference, Autobiography and History." *Literature and History* (Spring 1988): 37–47.

Young, Elizabeth. "Trash Tales." *New Statesman and Society* 8 January 1993: 41–42.

Young, Iris Marion. "Pregnant Embodiment: Subjectivity and Alienation." *Journal of Medicine and Philosophy* (1984): 45–62.

Zandy, Janet. *Calling Home: Working-Class Women's Writings: An Anthology.* New Brunswick: Rutgers UP, 1990.

Zebroski, James Thomas. *Thinking Through Theory: Vygotskian Perspectives on the Teaching of Writing.* Portsmouth, NH: Boynton/Cook, Heinemann, 1994.

Index

absence, of mother: dialogue and, 12, 20, 83; and inaccessibility, 12, 15, 20, 25, 31; space and, 18, 22, 30. *See also* death

Allison, Dorothy: body and, 59–60; class and, 12–13, 56, 58–59, 62–65; genre and, 57–58, 61, 65; narrative elements of, 63–64; writing praxis of, 60–62

ambivalence: toward children, 64, 97; geographical, 27; maternity as metaphor for, 98–99; toward mother, 21, 24, 39–40, 51–52; toward mother/daughter bond, 39–40, 60, 77

Anderson, Linda, 18

"And the One Doesn't Stir Without the Other" (Irigaray), 3

Angelou, Maya, 89

anger: in Allison's text, 59, 61, 63; in Lorde's text, 51–52; at mother, 3, 24, 39–41; at mother's absence, 20, 30; of mother, 64, 92, 94, 97; patriarchy and, 27, 48, 49, 82, 83

architecture, 18, 22–23, 26, 29–31

Art and Answerability (Bakhtin), 9

"Assembling Ingredients: Subjectivity in *Meatless Days*" (Warley), 26–27

"At the Threshold of the Self: Women and Autobiography" (Anderson), 18

"Author and Hero in Aesthetic Activity" (Bakhtin), 9

"Autobiographical Pact, The" (Lejeune), 4–5

"Autobiographical Pact (bis), The" (Lejeune), 4, 5–6

autobiography: and boundary with biography, 6–7, 11, 86, 89, 103n. 4; collaborative, 13, 71–72, 75–77, 85; as genre, 4–6, 9–10, 89, 103n. 4; Smith on, 36, 37, 52; in the third person, 57–58

"Autobiography of Those Who Do Not Write, The" (Lejeune), 71–72

autonomy: ambivalence about, 29, 39–42, 44, 65, 89; daughter's desire for, 44, 65, 77, 79–80; genre boundaries and, 1–3, 14, 86; from siblings, 22. *See also* identity; subjectivity

Bachelard, Gaston: on imagination, 17, 34; psychological theories of, 12, 16–17, 19, 21, 23, 30–31; on time, 17, 29

Bakhtin, Mikhail M.: dialogue theory of, 1, 7–11, 40, 50, 84, 89; social identity theory of, 8, 103n. 5

Balent, Alice, 3

Balent, Michael, 3

Barker-Nunn, Jeanne, 72

Bastard out of Carolina (Allison): betrayal in, 63–64, 65; body in, 59–60; class in, 12–13, 56, 57, 58–59, 64–65; genre and, 57–58, 61, 65; writing of, 60–63

bathing, 35, 38, 50, 51, 52

Benjamin, Jessica, 79

bilingualism: Spanish-English, 37, 42–43; Urdu-English, 15, 25, 26, 28

biography: and boundary with autobiography, 6–7, 11, 86, 89, 103n. 4; as a genre, 5–6, 9–10, 13–14, 86, 89

birth, 4, 38, 40–41, 82, 99; imagery, 21, 51; mother's experience of, 40–41, 92, 95. *See also* pregnancy; reproduction

bodies: class and, 57, 59–60, 64; connection through, 30, 36–37, 39–40, 43, 100; dance and, 53–55; death and, 18, 30, 31, 48–49; images of, 38–39, 41, 45; language of, 46–47; and menstruation, 35, 38–39, 41, 73, 86; politics and, 36, 37, 44, 48, 96; power and, 13, 57, 59; sensuality and, 41, 50–51, 52, 65, 95; separation from, 23–24, 31. *See also* birth; pregnancy; reproduction; sexuality

Booth, Wayne C., 8
boundaries: subject/object, 1–2, 7, 11, 76. *See also* autonomy; genres

Calling Home (Zandy), 62
capitalism, 2
Chernin, Kim: collaboration by, 13, 71, 75–78, 85; photographs and, 78–79; storytelling and, 70–71, 72–73, 85; time and, 73–74
Chernin, Rose, 71, 76, 78–79
Chesler, Phyllis, 92
Chicanas. *See* Latinas
Chodorow, Nancy, 3
chronology. *See* linearity; time
Cixous, Hélène, 3, 52–53, 65, 73
class: difficulty in changing, 47, 64, 66; identity and, 59, 62, 105n. 4; material envy and, 56–57, 59, 67–69; patriarchy and, 65–67; reproduction and, 13, 58, 59–60, 64–65, 66; writing praxis and, 61–63, 65
clothing: class and, 13, 56–57, 59, 64, 67–69, 104n. 1 (chap. 4)
Colette, 79
colonialism, 18, 26–27
"Compulsory Heterosexuality and Lesbian Existence" (Rich), 52
confessional literature, 36–38, 49, 52, 97
connectedness: feminism and, 2–3, 10, 35–37, 99; genres and, 7, 9, 37, 95; between mother and daughter, 39–40, 41–43, 48–49, 60–61, 96–97. *See also* autonomy; dialogue; love; marriage
conversation. *See* dialogue

dancing, 53–55
daughter, subject bias of, 14, 89–90
Davies, Carole Boyce, 71
death, 104n. 2 (chap. 2); of Allison's mother, 61, 63; ambivalence after, 21, 24, 39; body and, 18, 30, 31, 48–49; dialogue and, 12, 15, 20, 39, 48–49; and elegy, 11, 18, 25, 30; space and, 19, 20, 21–22, 23
de Milosz, O. V., 15

Depression, 56, 60, 67–68, 69
dialogue: Bakhtin on, 1, 7–11, 40, 50, 84, 89; bodies and, 35, 40, 46, 51; monologic voice contrasted with, 2, 8–9, 10, 11, 95; mother-daughter relationship and, 20, 28–29, 41–42, 49, 70–71, 83–86; silence in, 11, 81, 84; subjectivity in, 6–11, 46; textual analysis of, 11–14; voice and, 40, 44, 70–71, 75–76, 89; writing praxis and, 2, 4, 6–7, 11, 13. *See also* storytelling
Diamond, Arlyn, 93
"Difference, Autobiography and History" (Yeo), 64
"Difference on Trial" (Stanton), 98
"Discourse in the Novel" (Bakhtin), 9
Duckworth, Gerald, 23
Duckworth, Stella, 19, 23

Ernaux, Annie, 89
ethnicity. *See* race issues

"Family Album, The" (Chernin), 78–79
father: absence of, 82; abuse by, 58, 63–64; class and, 64, 65–67; symbolic realm of, 3, 10; women and, 28, 38–39, 41, 64, 65. *See also* marriage; patriarchy
Felski, Rita, 36–37
feminism: and confessional literature, 36–38, 49, 52, 97; and literary theory, 2–4, 10, 89, 90, 91; motherhood and, 92, 97; personal experience of, 93–94; and political liberation, 42–43, 47, 82–83; writing praxis of, 1–2, 11, 46, 52–53, 70–71, 86. *See also* liberation; politics
"Fisherwoman's Daughter, The" (LeGuin), 93

Gagnier, Regenia, 46
genres: autobiography/biography, 6–7, 11, 86, 89, 103n. 4; biography, 5–6, 9–10, 13–14, 86, 89; class and, 61, 65; combinations of, 37, 52, 84, 96; feminist confessional, 36–38,

Jo Malin is an administrator at the State University of New York at Binghamton in the Office of the Provost and Vice President for Academic Affairs. She was born in St. Louis, Missouri, and holds degrees from Washington University, Indiana University, and the State University of New York at Binghamton.